Tools as Art

The Hechinger Collection

All photographs by Joel Berger except the following:
By Edward Owen: Samaras; Schuette (Crosscut Saw); Hansen; Frabel; Arman
(School of Fishes); Tinguely; Crowley; Evans; Plowman (Still Life with
Tenon Saw); De Jonge; Dine; Estes.
By Michael Black: Lipski; Otterness; Chezhin; Butler; Solinas; Edwards;
HELMA; Jakober; Elvig; Webster.
Courtesy of Spanierman Gallery: Red Grooms.

The following biographies are written by Sarah Tanguy:
Carruthers; De Jonge; Delvoye; Dine; Drasler; Edwards; Eggleston;
Elvig; Estes; Fantazos; Finster; Frabel; HELMA; Heneberger; Horner;
Jakober; Leger; Lipski; Oldenburg; Otterness; Puustak; Red Grooms;
Salamun; Schlesinger; Schuette; Shimomura; Surls; Thiebaud; Tipping;
Wall; Webster; Westermann; Wideman; Wiley.
The following biographies are written by Jane Levine:
Abbott; Arnold, C.; Avvakumov; Benes; Butler; Butt; Carter; Chase;
Crowley; Edgerton; Evans; Francis; French; Gryzybowski; Gustafson;
Kass; Kostabi; Kudryashov; Lawrence; Mansfield; MANUAL;
Mr. Imagination; Plowman; Pond; Puustak; Solinas; Yes.
The following biographies are written by Carolyn Laray:
Brouwer; McDowell.

Published by International Arts & Artists, 2002

www.artsandartists.org

Editor: Penny Kiser

Design by Nynke de Haan

Printed & bound by Craft Print, Singapore

ISBN 0-9662859-1-3

Front cover: *Untitled* by Andrey Chezhin, 1994,
gelatin silver print, 5 7/16" x 11" (see page 30)
Back cover: *Hardware Store* by Berenice Abbott, 1938,
gelatin silver print, 10 1/2" x 13 1/2" (see page 18)
Inside cover: Now The Lord God Planted...by Charlie Brouwer, 1992,
treated and stained wood, 72"x50"x6" (see page 24)
Frontispiece: *Untitled* by Peter Gryzybowski, 1990,
oil on canvas, 50" x 36" (see page 48)

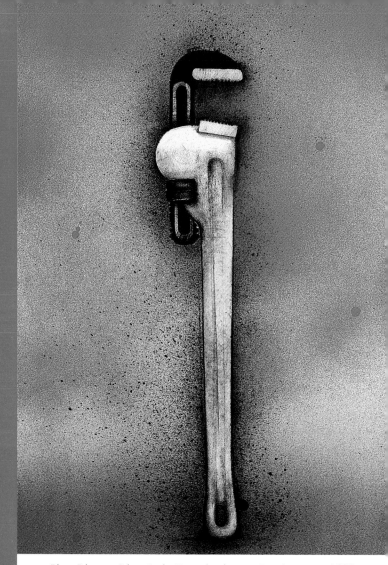

Jim Dine, *Big Red Wrench in a Landscape*, 1973,
color lithograph, 30"x22" (NOT IN EXHIBITION)

Participating Museums:

City Museum, St. Louis, MO
Contemporary Art Center of Virginia, Virginia Beach, VA
Peninsula Fine Arts Center, Newport News, VA
The Cedar Rapids Museum of Art, IA
Joslyn Museum of Art, Omaha, NE
Palmer Museum of Art, Pennsylvania State University,
University Park, PA
DeCordova Museum and Sculpture Park, Lincoln, MA
Charles Avampato Discovery Museum, Charleston, WV
Louisiana Arts Guild, New Orleans, LA
Leigh Yawkey Woodson Museum of Art, Wausau, WI
Minnesota Museum of American Art, St. Paul,MN
Palm Springs Desert Museum, Palm Springs, CA

A portion of the Hechinger Collection has
been on continious view at the National Building Museum,
Washington D.C., since 1997 - www.nbm.org

Contents

Brilliance is manifest in many forms. An absolutely new idea can be brilliant, as can be a combination of older innovations that together make something new, exciting and exquisite.

John Hechinger's simple and clear observation that there was an unarticulated relationship between the tools in his hardware stores and the world of artists and their art was—and remains—a brilliant thought. He subsequently transformed this idea into reality through nearly twenty-five years of developing an art collection focused on the relationships between tools and art.

Pier Gustafson, *Drill Press*, 1982,
All paper construction with pen and ink,
70x30x18" (NOT IN EXHIBITION)

As a collector, John Hechinger sought the broadest range of connections between these two interrelated worlds. He found both famous and lesser-known artists for whom various metaphors, such as *tools and creation*, or *work as labor versus works of art*, were recurrent themes. The Hechinger Collection also incorporates "high" art and "low" art, folk art and fine art, crafts and conceptual art. There is a certain consistency to this thinking as "tools" themselves are beyond categorizing by status or class, and they lack social boundaries, as should art.

Although the Hechinger Collection has work by over two hundred and fifty artists, no major artist is better represented than Arman, whose work often embodied the "tools as art" theme. Several of Arman's past solo exhibits spoke directly to his own fascination with this concept, and thereby to the mutual appreciation that he and John Hechinger share for each other's ideas.

Sarah Tanguy has been the curator for the Hechinger Collection for eight years and has repeatedly brought "Tools as Art" into public view. She has clearly adopted John Hechinger's vision that the value of the Hechinger Collection is in its collective form presented as a theme. This is a vision that we, at International Arts & Artists, also share in our effort to expose the American public to this wonderful collection.

Certainly there is great complexity in placing works of art on a national tour to nearly a dozen museums and developing the various attendant programs and materials to accompany them. Producing this catalogue could not have been done without the competencies of International Arts & Artists' committed staff, interns, and everybody else involved in the process. We also thank June Hechinger and others in the Hechinger family for their endorsement of the tour. Mrs. Hechinger allowed much-loved art from their home to travel afar.

The Hechinger Collection now has nearly four hundred works of art, a portion of which is represented in this intriguing touring exhibition. Having seen how easily the public relates to this collection and its theme, we are grateful to John Hechinger, not only for the idea and the loan of these works for this touring exhibition, but also for demystifying contemporary art and for helping art return to a place where it can be appreciated by all.

David M. Furchgott, President of
International Arts & Artists

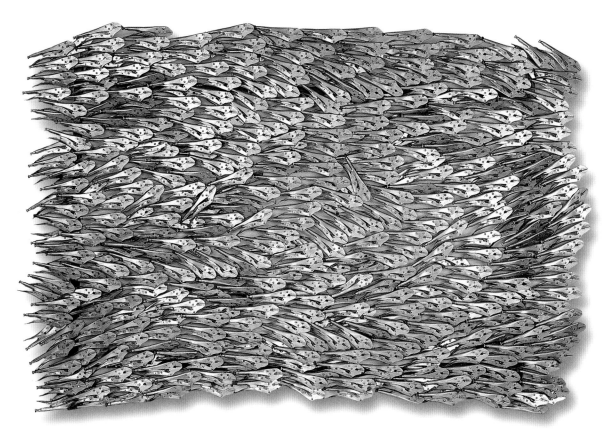

Arman, *School of Fishes,* 1982
Welded steel and visegrips
64x96x3" (NOT IN EXHIBITION)

Arman: or Art as Tools

As homo sapiens we still show the presence of "homo faber" or "man, the maker." This implies that we are well aware that we were—and still are—makers: workmen, craftsmen, artisans.

One of my main interests, as an artist, has been the constant representation or use of the common object in my work. One major museum retrospective of my work was entitled "The Adventure of Objects," and the majority of the objects shown were works constructed from tools.

I have noticed that objects are generally made for us and by us, for our goals and tasks. Among these objects, tools are the most recognizable as they have evolved to become a better fit for our hands.

At one point, I made an entire show called "Artist's Tools," based on the paraphernalia used by artists. There were paint tubes, paint brushes, palettes, palette knives, crayons, pencils and other objects which I incorporated into the work by various methods such as accumulations and embodiments in polymers. I also used the impression of the forms of these artists' tools in sculptures, works on paper, and prints.

"Tools as Art," both the premise and title of John Hechinger's collection, is the culmination of a relationship between man and his tools. This relationship of man and his tools is defined and enhanced by the artistic interventions and transformations of the tools represented in the art seen in this exhibition. In "Tools as Art: The Hechinger Collection," John Hechinger's discerning and keen eye has amassed an important group of works worthy of museums.

ARMAN

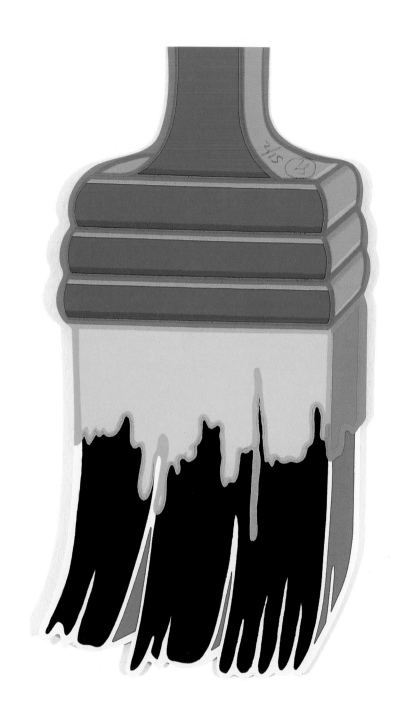

Lucas Samaras, *Brush*, 1968
Silkscreen relief, 6"x5"
(NOT IN EXHIBITION)

Instruments of Change

What if we reached for a hammer only to discover it was made of glass? Or we were about to climb a stepladder and realized it was a paper simulacrum? Typically, we go about our daily chores not thinking twice about the hammer we pick up or the ladder we step on. That is, unless the tool is broken or we hurt ourselves. We are so close to them that we no longer marvel at their economy of form and their elegance of design. The art collection of hardware industry pioneer John Hechinger awakens our appreciation. It celebrates the ubiquity of tools in our lives with art that transforms utilitarian objects into fanciful works of beauty, surprise and wit. Bereft of their familiar function, we discover new ways to look at these mundane tools that have been handed down from generation to generation. Something has changed, although at first we're not always exactly sure what.

Consider *School of Fishes* (see page 8), the quintessential example of morph and magic, the two pillars of the collection. From afar, we see a shiny, silvery mass of swimming fish. Up close, the mass breaks up to reveal its singular building block—the humble visegrip. The masterful Arman has stumped us once again with one of his extraordinary accumulations and stirred our own creativity!

In viewing the collection, we also come to appreciate the parallel tracks it represents. The ingenuity needed to create a new tool complements the boundless imagination and the myriad strategies of artists who have incorporated tools in their imagery. Judging the aesthetics of various industrial objects, for example, a team of designers in 1980 awarded the winning grade to an eight-penny finishing nail, which one of them described as "a truly classic design, one of the little

miracles that cannot be improved upon." Yet in the chilling photograph of Andrey Chezhin (see page 30), a nail has become the sole feature of a ghostly white face. Improvising on the absurdist writings of Russian modernist D. Kharms, Chezhin's portrait of an anonymous Soviet may symbolize the final do-it-yourself project.

Until he retired in 1995, John Hechinger headed the Hechinger Company, a hardware and building materials chain established by his father in 1911. When the company moved to new headquarters in 1978, he found the corridors and workplaces efficient but sterile: "The building seemed to rebuke the fantasies that a hardware store inspires. For anyone whose passion is work with his

or her hands, a good hardware store is a spur to the imagination and a source of irresistible delights." He called on his friend and noted designer, Ivan Chermayeff, to enliven the walls. His innovative solution was to create over eighty, eye-catching and nearly abstract kodaliths—photographic prints that have no halftones—of merchandise sold in their stores.

Hechinger already owned *Tool Box*, a suite of silkscreen prints where Jim Dine playfully combines various tools with images from Pop culture and his personal life. Together with the kodaliths, they fueled his search for paintings, sculptures, works on paper, photographs, and crafts that highlighted not only the family business but also the can-do spirit of the American experience. In displaying them throughout the building, they became the subject of endless discussion and a source of pride. "It was the hope that surrounding employees with artistic expressions of the same objects they handled in the tens of thousands would bring a sense of dignity of their jobs," Hechinger notes. In 1998, the collection left its original setting for public view. At present, it exceeds 375 works by 250 leading masters and emerging artists, mostly American from the post-World War II era. As Hechinger discovered early on, the collection's tight focus strikes a rich and diverse vein in modern art,

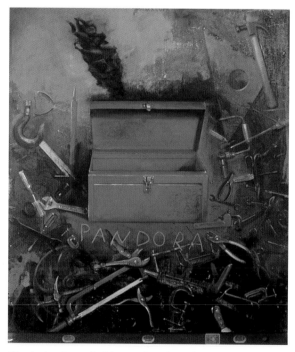

Christopher Pelley, *Pandora's Box*, 1996, oil on linen, found objects, 56x48" (NOT IN EXHIBITION)

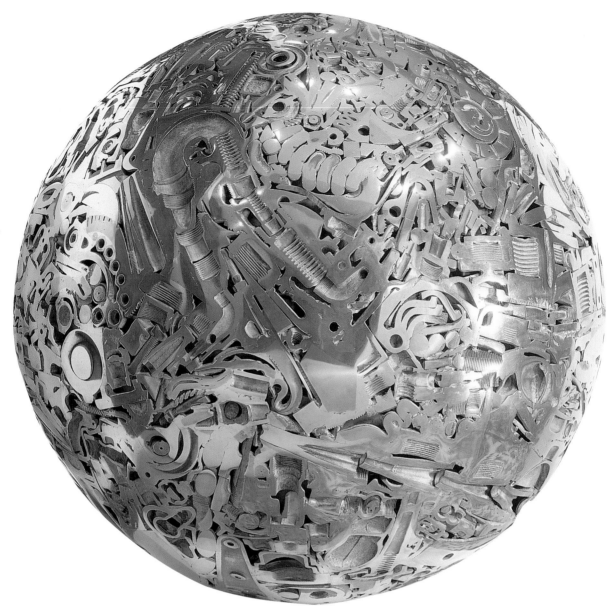

Micael Malpass, *Newtonian Sphere III*, 1989, bronze, brass, copper, and silver 28" diameter (NOT IN EXHIBITION)

encompassing a broad range of themes and styles. Yet each acquisition reflects a meeting of the minds between the artist's imagination and Hechinger's vision.

Since the prehistoric age, tools have inspired countless artists to feature them in their work. "When you go to the caves in France and look at the drawings of the cave men and women you see their tools along with the bison," Hechinger observes.

Ladders, for example, have appeared in medieval illuminations of the Tower of Babel, and a shovel is the clue left behind in Eugene Delacroix's nineteenth-century painting, *Hamlet and Horatio in the Graveyard*. It was not until the twentieth-century, however, that tools entered the artistic mainstream. They became a clever means to bridge art and life and to address the shifting definition of perception itself. As extensions of

our hands and minds, they also give us valuable insights into the progress of civilization and the collection, in turn, into the history of art. "In many of the religious panels of the Renaissance, you see the same tools as carpenters use today. They haven't changed at all since then, so they've become a symbol or order and aspiration for me," in the words of Jacob Lawrence.

By tracing the change in production from hand to industrial to computer, the collection is a wonderful time capsule. In Christopher Pelley's enigmatic painting, *Pandora's Box* (see page 10), tools scattered around an opened tool chest signal their seminal role in

Jean Tinguely, *Tools85, 1985,* motor-driven construction of hardware and tools 36x24" (NOT IN EXHIBITION)

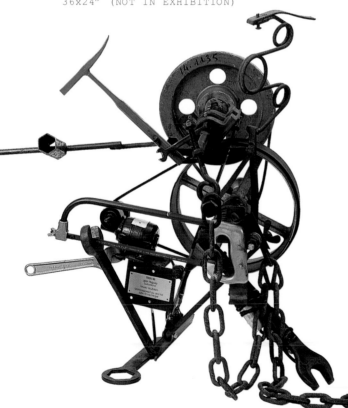

human history, while warning of their potential for both destruction and construction. Other works like Jacob Kass's painted saw of a snowy, pastoral landscape (see page 54) are tinged with bittersweet nostalgia about the passing of hand labor. Ben Jakober spoofs an archeological dig in his stone sculpture *Anonymous Fossil No. 2* (see page 53), which features the negative and positive form of a hammer, the very tool used to split the stone. At the other end of the timeline, Malpass's *Newtonian Sphere* (see page 11), a welding tour-de-force, recycles an assortment of tools into a glistening post-industrial relic. On a more irreverent note, Jean Tinguely's *Tools85* (see bottom left of page) critiques the roles of machines and consumption. At set intervals, the clanking apparatus comes to life, with each tool performing its customary action to no purpose. "Yet," as Hechinger notes," the act of working itself is quite beautiful, and the lowly items, often thought beneath artistic consideration, celebrate themselves and will be heard."

One of the underlying currents of the collection is the seeming paradox between the autonomous, mass-produced tool and its transformation into a unique expression of an artist's imagination. Walker Evans, who admired the "fine naked impression of the heft and bite in the crescent wrench," makes a time-

less photographic portrait of this tool (see page 44): "Among the low-priced, factory-produced goods, none is so appealing to the sense as the ordinary hand-tool. Hence the hardware store is a kind of offbeat museum show for the man who responds to clear 'undesigned' forms." By contrast, Lucas Samaras turns a commercial paintbrush into a stylized Pop icon (see page 8), while in *Blue, Red, Brown* (see page 19), Arman cleverly makes a painting about painting by affixing actual paintbrushes, loaded and caught in action, onto canvas. In Chester Arnold's *Correction* (see page 21), a giant hammer is pulling out a misplaced nail, and in the middle distance, a plume of smoke suggests an unseen disaster awaiting rescue. Stephen Hansen goes so far as to show a hapless man about to saw himself of plank, whose goofy expression makes it clear that he is oblivious of his impending fate (see page 14).

Put another way, the collection often blurs the distinction between high and low art by identifying art with labor and tools, and stressing the basic fact that artists use tools to create art. Although many opt to make the finished product seem effortless, much of the magic in the collection stems precisely from the way artists recognize the importance of tools and hardware in their work. To honor the hardware used to build his grandmother's

house and the tools of the trade employed in the Hippodrome, Manhattan's biggest theater, Red Grooms creates a surreal image of a giant hammer about to pound sun-

Holis Sigler, *The Perfect Heart Is Only a Dream*, 1990, Oil pastel on paper, carved and painted frame, 33x39" (NOT IN EXHIBITION)

shaped boards into plywood, cloud-filled skies (see page 72). Similarly, the legendary evangelist turned artist, Howard Finster, equates tools with civilization and patriotism as evidenced in the painting and text on a Stanley Thrift saw: "Mountains of people use tools…Tools came first and America came second. Without tools we could not maintain the world. Humans and tools belong together…." (see page 45). Other artists endow tools with a spiritual force. An enclosed garden and tools become a symbol of healing in Hollis Sigler's *The Perfect Heart is Only a Dream* (see above), and Charlie Brouwer's sculpture of a winged shovel, *Now the*

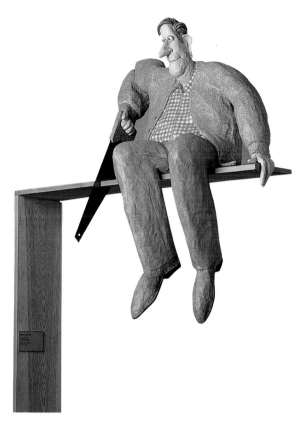

Stephen Hansen, *Man on a Limb,* 1985, Papier-mâché, 48x72" (NOT IN EXHIBITION)

Lord God Planted (see page 24), explores the transcendental power of art to take "us places that cannot be reached by other means."

Many of the works incorporate found objects as a means to break down the barrier between art and life and as a way to give new life and meaning to the detritus of society. This tradition, which started in the early part of the twentieth century with Pablo Picasso and Marcel Duchamp, continues to be an active strategy today. By substituting a drill for the earpiece of a dial phone, for example, Richard Tipping's *Drill-a-Phone* (see page 84) plays with the expression of having someone talk your ear off. By

contrast, Ken Butler employs an array of tools to fashion his *Saw Blades/Scythe/Guitar* (see page 25), which can be played as a percussion instrument: "From the storehouse of forsaken objects and hardware, I, the urban bricoleur, further dismantle and reassemble the consumer society into functional assemblages, then coax them to sing for their dinner." Other works explore the nature of tools and hardware within a socio-political context. Melvin Edwards imbues his welded steel collage using found objects with the African American legacy of struggle and survival (see page 38). Mr. Imagination extends this idea by giving his recycled paintbrushes individual personalities with faces of beads, bottle caps, and other cast-offs, suggesting African dignitaries he saw during a four-week coma (see page 65).

Perhaps, the most striking aspect of the collection is the magical transfer of tools from the domain of the functional into the world of fantasy through change in material and scale. Several artists exploit the illusionistic properties of materials. Hans Godo Fräbel freezes the action of a hammer and nails, improbably out of glass. Gone is the power of the hammer, the utility of the nail. But their forms are perfectly preserved and exactingly rendered to scale (see page 46). John Mansfield's *Zen Saw II* (see page 63) performs an even more

unlikely feat—his tool made of rice paper and bamboo is able to cut a slab of granite into slices. By contrast, F.L. Wall manipulates the scale of the tools he portrays in his sculptures: "By making them large and in wood, I lift them out of the realm of the routine and force people to look at them differently, as aesthetic objects." (see pages 16 and 85). Equally radical are works that deploy *trompe l'oeil* to achieve a visual slight of hand. James Carter's oil painting of a paint can and tools (see page 28) and Peter Gryzybowski's painted strip of oak (see page 48) are so convincing that we want to touch them to assure ourselves that they are only canvas.

Humor runs throughout the collection causing delight and surprise. The use of verbal and visual puns as a means to overturn rational anticipation is clearly evident in Henryk Fantazos' *Women in Labor* (see page 44), a rendering of bejeweled ladies in elegant attire on a work site, and in Vladamir Salamun's *Siamese Hammer Joined at the Handle* (see page 74), which plays off the adage, "two heads are better than one." Other artists ascribe human attributes to tools and hardware. A common hammer with nails akimbo becomes a surrogate of a careless worker in H.C. Westermann's *The Slob* (see page 87). And in Claes Oldenburg's print after his three-dimensional "software" series, an

oversized three-way plug grins at the viewer: "I am for an art that takes its form from the lines of life, that twists and extends impossibly and accumulates and spits and drips…." (see page 67). As a clever homage to Oldenburg and a critique of monetary power, Ray Beldner stitches together a soft toilet out of dollar bills in *Down the Toilet* (see below) from his Counterfeit series.

One of the great rewards of the collection is uncovering its wealth of interrelations. The same material can produce different tools. Wood, for example, can become a paint tub and brush or a lathe. Conversely a tool can appear in various guises.

Ray Beldner, *Down the Toilet*, 2000
Sewn dollar bills, wood, metal and velcro
33"x 20"x 25" (NOT IN EXHIBITION)

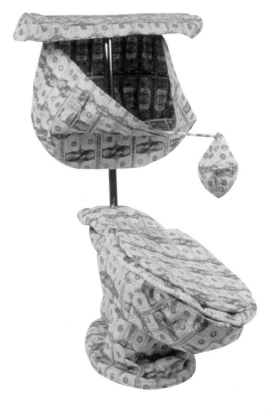

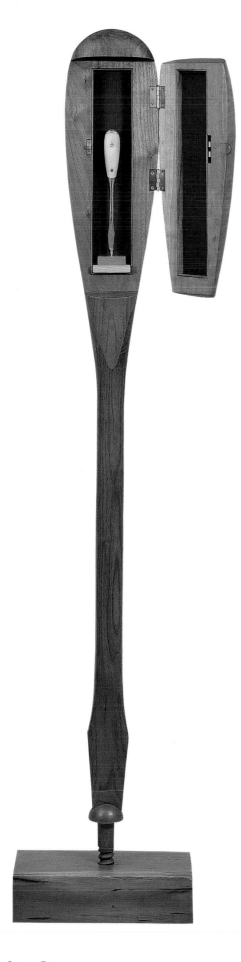

Saws can portray a love scene or
suggest the repair after a hurri-
cane. More importantly, the tools
depicted engage us in dialogue. They
awaken childhood memories and hint
at future possibilities. Because
they are such a basic part of human-
ity, the collection's focus on ob-
jects and their metamorphosis into
art appeals to the building in all
of us. By turns, humorous and seri-
ous, these remarkable works are sure
to challenge expectations and stir
the imagination. We invite you to
enjoy the exuberant creativity,
consummate craft, and sheer fun of
the collection. As Hechinger notes:
"It's not just an understanding of
the humor and artistry of a particu-
lar piece, but an appreciation of
how the collection fits the general
theme of tools in the work place,
tools in life, and tools as art."

Sarah Tanguy, Curator of the
Hechinger Collection

For more information about the
Hechinger Collection, please visit
w w w . t o o l s a s a r t . c o m

F.L. Wall, *Screwdriver, 1979,* ash,
cherry, mahogony, and walnut, 22"x10"x66"
(NOT IN EXHIBITION)

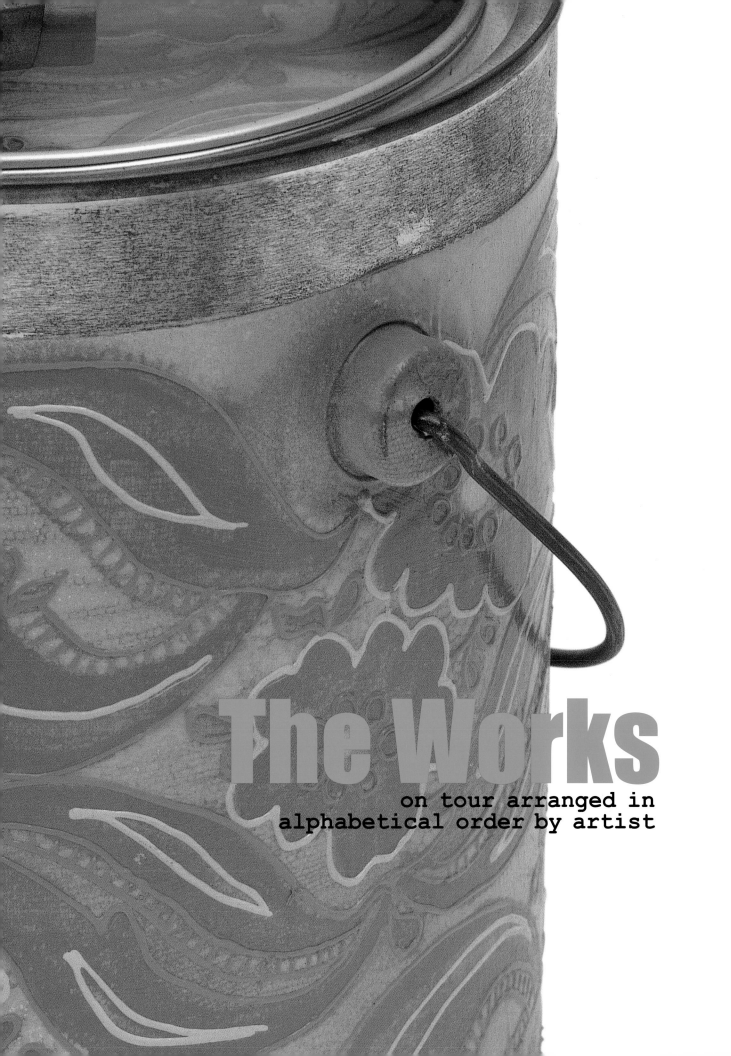

The Works

on tour arranged in
alphabetical order by artist

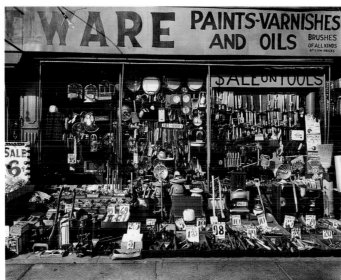

Hardware Store
1938

Bernice Abbott was born in Springfield, Ohio, in 1898. She died in 1991 in Monson, Maine, at the age of ninety three. After studying at Ohio State University, she went to New York in 1918 intending to become a journalist but studied sculpture instead. She moved to Paris in 1921 to continue her sculpture studies and spent time in the studio of Constantin Brancusi. When Man Ray hired her to be his dark room assistant in 1923, she began making her own photographs. From 1926 to 1929 she had her own studio in Paris and began making her own photographic portraits, primarily of the avant-garde intelligentsia, including James Joyce, André Gide, and Jean Cocteau. She also met the French photographer Eugene Atget, who was to greatly influence her work. She acquired his entire collection of photographs upon his death. (The collection is now at the Museum of Modern Art in New York.) In 1929 she returned to New York and began photographing the city and its inhabitants. In 1935 Abbott received a grant from the Federal Arts Project's "Changing New York" program to continue this project, and from 1935 to 1939 she produced extensive photographic documentation of the city, culminating in the book Changing New York (1939). During the 1940s and 1950s she developed her own photographic equipment and techniques to illustrate scientific principles such as gravitational pull and the properties of objects in motion. In the mid-1960s she moved to Maine, where she lived and worked until her death. Abbott thought of the camera as an instrument of truth, and her photographs attempt an objective description of the external world. By communicating a wealth of detail about the subjects she documented, Abbott sought to establish the verity of her images.

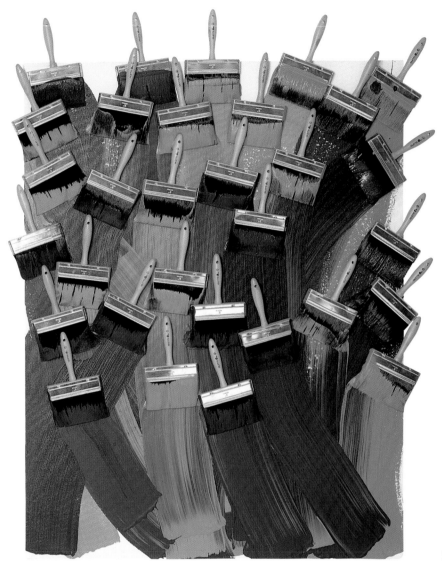

Blue, Red, Brown
1988

Arman

Born the son of an antiques and secondhand furniture dealer and amateur cellist in Nice, France, in 1928, Armand Fernandez gave up his surname in youthful emulation of Van Gogh, and in 1957 he became Arman when a typesetter dropped the "d" from his name. He is a founding member of New Realism with artists Yves Klein, Jean Tinguely and theo-rist Pierre Restany. His formal training included studies at the National School of Decorative Arts in Nice and the Louvre School in Paris. After a brief military service in Indochina, he turned his attention to abstract painting and embarked on a series of "happenings" and events with Yves Klein. From 1947 to 1953 he became involved with

Zen Buddhism, the Rosicrusians, Gurdjieff, and astrology. Around 1960 he began creating his "rages" (colères), and "accumulations." His "accumulations," or constructions, have incorporated such ordinary objects as pliers, shoetrees, and wrenches, as well as scrapped industrial goods, broken bicycles, and discarded phonograph records, which he composes into broad, allover patterns. Other works have featured paint tubes embedded in Lucite or Plexiglas, with the paint partially squeezed out to form sculptural objects or self-referential paintings. His complementary series, "rages," consists of musical instruments and other single objects that have been reduced to fragments. In 1961 he had his first New York show at the Cordier-Warren Gallery and was included in "The Art of Assemblage" at the Museum of Modern Art. He took up residence in New York in 1963, becoming friends with Andy Warhol, Frank Stella, and Robert Rauschenberg. In 1964 he had his first solo museum show at the Walker Art Center in Minneapolis, followed by one at Amsterdam's Stedelijk Museum. In 1967 he began an "Art-Industry" collaboration with Renault, the French car manufacturer. He taught at U.C.L.A. from 1967 to 1968. His work has been shown throughout the world, including the Venice Biennale and Documenta. Arman is notorious both for his large-scale installations and for his public "destructions," which have included dynamiting a sports car. In recent years, his works have become more introspective, as seen especially in his encrusted bronze castings of ordinary objects. But as in his earlier work, the deliberate, orgiastic redundancy of his mature style offers a critique, at times humorous, of the excesses and eccentricities of modern life. A traveling retrospective of his work was held in the U.S. in 1991 and 1992, and a European tour that began in France in 2000 and ended in Boca Raton, Florida, in 2000.

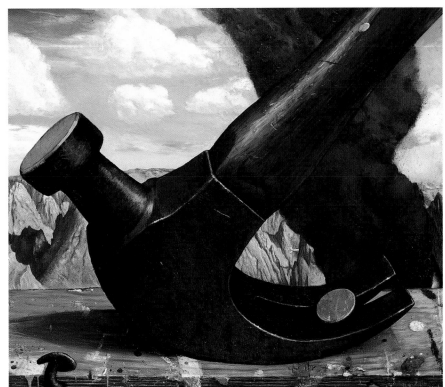

Correction
1987

Chester Arnold

Born in Santa Monica, California, in 1952, Chester Arnold studied at the College of Marin, Kentfield, California, from 1970 to 1974 and went on to earn his M.F.A. from the San Francisco State University in 1987. Arnold has had regular solo exhibitions at galleries in California since 1979. He taught classes in drawing and painting at San Francisco State University and the San Francisco Art Institute. Arnold's paintings explore different themes in various series. His work is filled with references to other art, including figures or settings from historical paintings. In the late 1980s Arnold did a series of tool "portraits" structured similarly to Renaissance portraits, with the sitter in the foreground and a distant landscape in the background. Many of these paintings showed building frameworks, construction activities or fires, suggesting continual cycles of creation and destruction.

*Stair Ladder
Barricade
1989-93*

Yuri Avvakumov

Yuri Avvakumov was born in Tiraspol, Russia, in 1957. He graduated from the Moscow Architecture Institute in 1981. Avvakumov is a sculptor, a printmaker, and a practicing architect with his own firm, AGITARCH Studio, in Moscow. His work has been exhibited in the U.S., Japan, and Europe, including the State Museum of Moscow, the Palazzo dell'Arte, Milan, and the Fondation pour l'Architecture, Brussels. In the early 1980s, he gained notoriety when he organized the show, "Paper Architecture," and helped establish a movement dedicated to this subject. Both personal and non-utilitarian, his and the conceptual designs of his colleagues were intended not as blueprints for actual buildings but as independent works of art. Avvakumov has been a member of the "Utopia Foundation" since 1993. In 1999 he represented Russia at the Venice Biennale, with "Russian Utopia: A Depository," which subsequently traveled to Rotterdam, Holland as well as Moscow and Volvograd, Russia. Ladders and exposed stairwells are recurring themes in his art and his architectural designs, including his series of three-dimensional models and works on papers, *Temporary Monuments.* Ladders are carriers of meaning, and symbols of construction and progress, or barricades. For the last several years, he has been involved with computer animation as well as creating a virtual museum and archive dedicated to conceptual architecture.

Reliquary/Pier 48
Hudson River
1982

Barton Lidicé Beneš

Barton Lidicé Beneš was born in New Jersey in 1942. He studied painting at the Pratt Institute, New York, in 1960-62 and graphics at the Académie de Beaux-Arts, Avignon, France, in 1968. Beneš excels in a variety of media, including sculpture, collage, and printmaking. His work has been widely exhibited at museums in the U.S. and abroad, including the Craft and Folk Art Museum, Los Angeles, and the Renwick Gallery, Washington, D.C., as well as in Sweden, Finland, Portugal and Canada. His work is included in the collections of the National Museum of American Art, Washington, D.C., the Art Institute of Chicago, and the Bibliothèque Nationale in Paris, among others. Beneš uses myriad, often unorthodox found objects as well as objects collected in his world travels to create his collages, sculptures, and assemblages. Often grouped thematically around such subjects as food, death, and hair, his works are witty explorations of societal customs and assumptions and often take the form of *reliquaria* or secular wall cabinets. In 1983 Beneš made a series of collages and paper sculptures from six million dollars in shredded bills he was given by the Federal Reserve Board. His pieces frequently include visual and verbal puns and are often crafted to look as if they were made from other media. In 2002, his work was the subject of a monograph, titled *Curiosa: Celebrity Relics, Historical Fossils & Other Metaphoric Rubbish.*

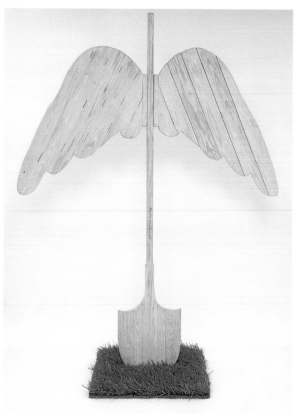

Now the Lord God
Planted a Garden...
1992

Charlie Brouwer

Charlie Brouwer was born in Holland, Michigan, in 1946. He received an M.F.A. in painting in 1980 and an M.F.A. in sculpture in 1984, both from Western Michigan University, Kalamazoo. Brouwer has taught high school in Australia and in the United States and has taught art at Radford University, Radford, Virginia, since 1987. He has shown at galleries and art centers throughout the U.S., Hungary and Poland, including exhibitions at the Art Museum of Americas Organization of American States, Washington, D.C., the Charles A. Wustum Museum of Fine Arts, Racine, Wisconsin, and the Art Museum of Western Virginia, Roanoke. His work is in the McDonald's Corporation Collection, the UpJohn Corporation Collection, the Notoro Collection of International Contemporary Art, Poland, and the International Outdoor Wood Sculpture Park, Nagyatad, Hungary. Brouwer employs a visual vocabulary of natural and artificial objects—including tools—as metaphors to express larger spiritual truth. With his use of tool imagery and his preference for raw lumber as a medium, Brouwer alludes to the perception that "in America, anyway, every man is a handyman." The simple, honest quality resulting from the simplicity of his medium, together with his rough-hewn, almost childlike style, lend his work an accessibility that gives way to deeper meanings.

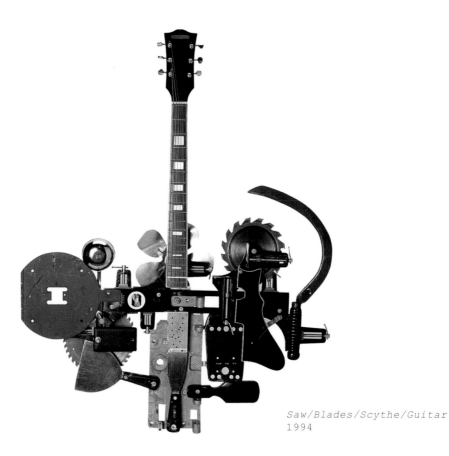

Saw/Blades/Scythe/Guitar
1994

Ken Butler

Ken Butler was born in Bethesda, Maryland, in 1948. As a child, he studied the viola and pursued his passion for music alongside his study of the visual arts in France, at Colorado College and at Portland State University where he earned his M.F.A. in painting in 1977. A year later, while rummaging in his basement, he noticed how the shape of an ax reminded him of a violin, and after adding strings, a bridge, and tuning pegs, he had conceived his first hybrid instrument. Since then, he has taken the experiments of Marcel Duchamp to new heights by transforming the likes of tools, sports equipment, boots, and other domestic items into hundreds of musical instruments. His collage drawings, performances and installations display a similar interest in exploring the interaction of everyday objects and manipulating image, sounds, and silence. He has participated in numerous exhibitions and performances throughout the U.S., Canada, South Africa, Thailand, Japan, and Europe, including the Lincoln Center, New York, and The Stedelijk Museum, Amsterdam. He has performed with John Zorn, Laurie Anderson, and Butch Morris, among others, and has produced his own CD, *Voices of Anxious Objects*. His work is found in public and private collections in the U.S. and Canada, including the Metropolitan Museum of Art, New York.

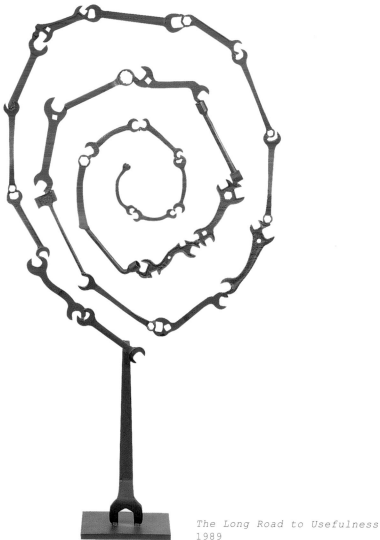

The Long Road to Usefulness
1989

Hugh R. Butt

Hugh R. Butt was born in Delhaven, North Carolina, in 1910. He earned his B.A. from the University of Minnesota and his M.D. from the University of Virginia in 1933. A doctor on staff at the Mayo Clinic in Rochester, Minnesota, Butt is also a self-taught artist who creates metal sculptures. His work has been shown at the Circa Gallery, Minneapolis, Minnesota, the University of Alabama in Birmingham, the Museum of Science in Houston and the Rochester Art Center, Minnesota. In the 1980s he made a series of sculptures using antique tools he had collected. The artist wrote that this group of sculptures "signifies my belief that it sometimes takes a long time before tools find their proper usefulness."

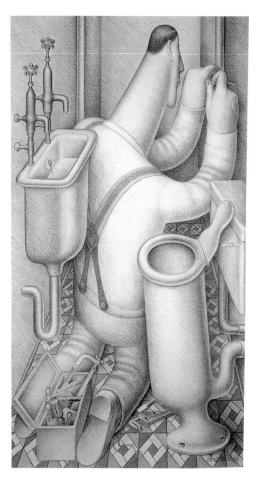

The Plumber
1980

Roy Carruthers

Born in Port Elizabeth, South Africa, in 1938, Roy Carruthers graduated from the Technical College of Art School, Port Elizabeth, South Africa in 1956. He is the recipient of the American Institute of Graphic Art and the Gold Medal Society of Illustrators in 1973, and his work is in the collections of the Ulrich Museum, Wichita, Kansas, the Weatherspoon Art Gallery, the University of North Carolina, Greensboro, the University of Wyoming, Laramie, and the Ponce Museum, Puerto Rico, among others. Whether it be expressed in a painting or a work on paper, Carruthers's signature style is hard to resist. He seamlessly transforms a sleeping woman, a plumber, the open shelves of a cabinet, the wooden flooring of an interior, a teapot, and other everyday objects through a curious distortion of proportion and a muted palette of warm earthy colors. Recalling the Surrealist experiments of Matta and Picasso, his manipulated images replace the expected geometry of the real world with a simple yet wondrous reverie.

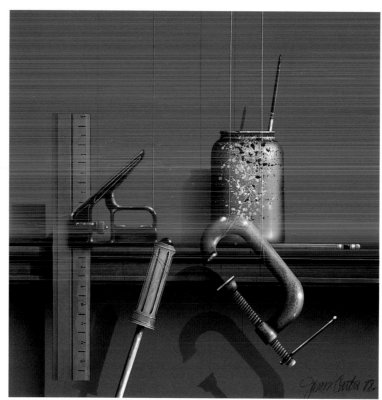

Paint Can and Tools
1988

James Carter

Born in Port Chester, New York, in 1948, James Carter studied at Silvermine College of Art in Connecticut and graduated with a B.F.A. from the Maryland Institute of Art. Carter's paintings and prints have been exhibited at the Zenith Gallery, Washington, D.C., the Horizon Gallery, New York, and the Bell Gallery, Greenwich, Connecticut. His still lifes display the influence of Surrealist painters of the 1930s, such as René Magritte and Max Ernst. Like the Surrealists, Carter juxtaposes unexpected objects – teacups, whales, and blue skies, for example – which often sit uncomfortably within his pictorial space. He has also been influenced by the nineteenth-century American *trompe l'oeil* painters William Harnett and John Peto, as demonstrated by the great detail and tactile presence of the objects in his work

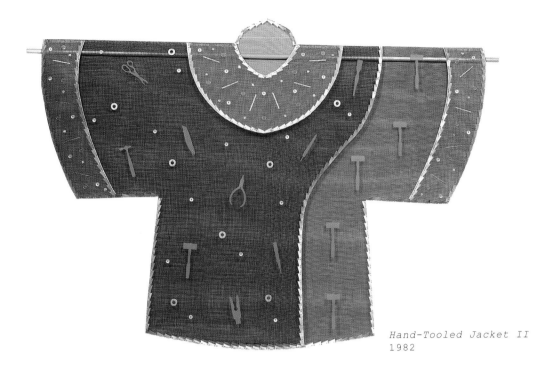

Hand-Tooled Jacket II
1982

Debra Chase

Debra Chase was born in Rochester, New York, in 1954, and died in New York in 1996. She received a B.S. in studio art in 1977 from Nazareth College, Rochester, and an M.F.A. from the School of American Craftsmen, Rochester Institute of Technology, in 1982. Her sculpture had been exhibited at the American Craft Museum, New York, the Albright-Knox Art Gallery, Buffalo, and the Renwick Gallery, American Art Museum, Washington, D.C. Chase sees her wall-mounted "clothing" of wire mesh as visual metaphors for rites of passage, celebrations, and various social states. Beginning with kimono compositions that were two-dimensional and meant to be displayed on the wall, Chase moved to larger, more three-dimensional constructions, including a series of "Life Jackets" that refer to meaningful but fleeting experiences from daily life. The mesh screening allows the artist to work with light and transparency while it serves as the ground for decorative, rhythmic patterns of elements such as tools, leaves, flowers, and figures.

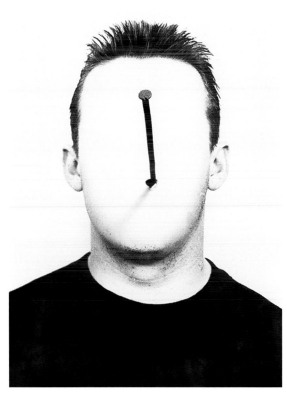

*Untitled
(from The
Kharmisiada Series)
1994*

Andrey Chezhin

Andrey Chezhin was born in St. Petersburg (then Leningrad), Russia, in 1960, and graduated from the Leningrad Institute of Cinematic Engineering in 1982. Until the fall of communism, he worked as a photographer for a construction company, which gave him access to its darkroom and materials for his own practice. From 1987 to 1994, he and two colleagues founded an idea-driven photographic group, TAK, and produce a number of shows. Since then, his work has been featured in exhibitions throughout Europe and the U.S., and is included in the collections of the Russian Museum, St. Petersburg, Brooklyn Museum, Brooklyn, NY, Museum of Fine Arts in Houston, TX and the Columbus Museum of Art, Ohio, among others. Ever fascinated by the illusive transparency of space and time, Chezhin mines a variety of sources for his photographic series, which typically involve sophisticated shooting and darkroom manipulation. His hometown is behind "City-Text," while he is the subject of "Self-Portrait: 366 days." Other series pay homage to seminal predecessors, including Kasimir Malevitch and Man Ray. "Kharmsiada" is dedicated to the author, D. Kharms. In this work, Chezhin culled discarded headshots from photo booths and replaced their features with hardware. Anonymous and disturbing, these re-contextualized images stand for the triumph of the Soviet citizen who has lost individual identity to collective obedience.

Graham Crowley

The Clampdown
1983

Born in Romford, England, in 1950, Graham Crowley attended the St. Marion's School of Art from 1968 to 1972 and the Royal College of Art, London, from 1972 to 1975. He was an artist-in-residence at Oxford University from 1982 to 1983 and was a visiting tutor at the Royal College of Art. Crowley's work has been shown extensively in England and Europe, including exhibitions at the Venice and Paris biennials, at the Fitzwilliam Museum, Cambridge, and at the Walker Art Gallery, Liverpool, and is included in a number of public collections. He has also completed several large-scale public commissions. Crowley worked originally as an abstract painter but began to paint figuratively in the 1970s. His influences include cartoons and comics, particularly the work of Walt Disney. His works – exaggerated images of ordinary objects – suggest a child's view of the world, in which household items are imbued with the potential to come alive. The disproportionate scale of Crowley's objects and his often-skewed perspective enhances this perception.

Brush and Tub
1982

Dies de Jonge

Dies de Jonge was born in Brouwershaven, Holland, in 1948 and completed his studies at the Art Academy in Rotterdam in 1974. He specializes in etching wood sculpture, and design. He has exhibited in Europe, the Far East, and the United States. His work is in several public collections, including the Municipal Museum in Amsterdam and the Boymans-van Beumingen in Rotterdam as well as many private collections in Europe and the United States. Labeled an Abstract Realist, De Jonge is fascinated by contemporary hand tools and sequential motion. He produces "portraits" that capture tools' actions and shapes at near-life-size scale.

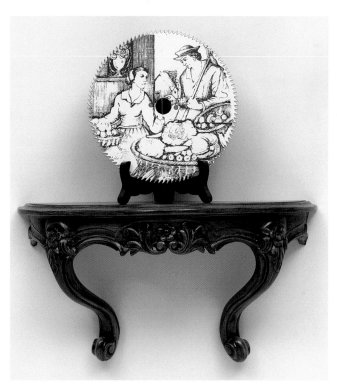

Leontine
1990

Wim Delvoye

Wim Delvoye was born in Werwick, Belgium, in 1965. His sculptures have been included in numerous exhibitions in Europe and the U.S. including the 1990 and the 1999 Venice Biennale, Documenta IX in 1992, Germany, and Sonsbeek 9 in 2001 in Holland. Delvoye's mixed-media sculptures reflect a witty blend of Dada and Surrealist sensibilities and a restless exploration of conventional materials put to highly unexpected use. He often juxtaposes banal, utilitarian objects with appropriated genre scenes, ornamentations, and references from the past, thereby confounding high and low art and questioning notions of identity, good taste, and functionality within a historic context. As the artist explains in a recent interview: "My work celebrates West-ern European suburban culture…I am out…to upset the art world by being bourgeois." In recent years, he has experimented with food imagery. In one photo series, he turns bits of different salamis into an eye-dazzling, *trompe l'oeil* rendition of a multi-part marble renaissance floor. In *Cloaca-New and Improved*, the artist has devised a machine that eats, digests, and defecates food in a darkly humorous commentary on the uneasy relation between man and machine and the uselessness of the art object in light of world starvation. The exhibition opened at MuHKA, Antwerp in 2000, and traveled to Migros Museum, Zurich, the New Museum of Contemporary Art, New York, the Museum Kunst-Palast, Dusseldorf, and the Porin Taidemuseo, Finland.

Jim Dine

Jim Dine was born in Cincinnati, Ohio, in 1935. He served as a bridge between Pop Art and a new generation of figurative expressionism, and continues to refine his technical virtuosity in paintings, sculptures, drawings, and graphics. From 1953 to 1955 he studied at the University of Cincinnati and the Boston Museum School, and in 1957 he received his B.F.A. from the University of Ohio. After a year of graduate work, he moved to New York in 1958. He taught at various schools in the New York area through 1961. In 1959 he exhibited with Claes Oldenburg at the Judson Gallery, his first New York show. During the early years in New York, his work combined real and painted objects, evolving from the theater pieces he made for the Judson Gallery "happenings." These expressionist assemblages reinterpreted Action Painting by presenting objects not as symbols but as real, contingent presences. In 1964 Dine was included in the Venice Biennale. He began his "Robe" series in 1966,

when he moved to London to distance himself from the Pop Art scene. In 1970 he moved to Vermont, and during the 1970s he taught at several New England institutions. In 1980 he was elected to he American Academy and Institute of Arts and Letters. The Whitney Museum of American Art, New York, gave him his first retrospective in 1978. A touring exhibition of his drawings began ten years later. Dine developed a love of tools at his family's hardware store, and they have remained a favorite subject throughout his career, along with hearts, palettes, and robes. In recent years he has added skulls, trees, gates, and the torso of Venus to his lexicon of images, and his work has been marked by a heightened sense of drama and sensual gestural surfaces. He is also experimenting with digital technology as a way to breath new life into his compositions contrasting tools with a painterly background

Jack
1987

Greg Drasler

Greg Drasler received a B.F.A. in 1980 and an M.F.A. in 1983 from the University of Illinois in Champaign. His paintings have been shown in New York, San Francisco, Newark, New Jersey, and Chicago and are included in several private and public collections. Drasler's quasi-Surrealist work, which often places oversize utilitarian objects and figures engaged in mundane tasks in forbidding or elusive landscapes, probes the netherworld between memory and dream.

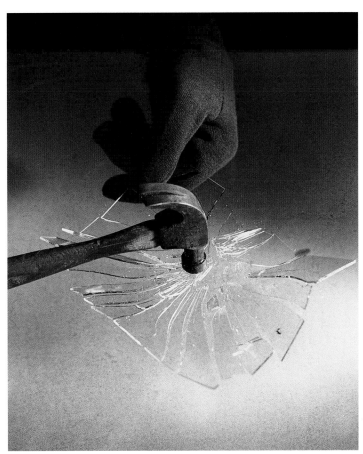

Hammer Breaks Glass Plate, 1933

Harold E. Edgerton

Harold E. Edgerton was born in Fremont, Nebraska, in 1903, and he died in 1990. He received a B.S. from the University of Nebraska at Lincoln in 1925 and earned an M.S. in 1927 and a Ph.D. in 1931 from the Massachusetts Institute of Technology. He was also a founding partner of Edgerton, Germeshausen and Grier, a technical products and services firm. His photographs have been exhibited internationally and are included in the collections of the International Museum of Photography, George Eastman House, Rochester, New York, the Centre Pompidou, Paris, and the Moderna Museet, Stockholm.

As an electrical engineer, he approached the medium as a means of scientific research and was a pioneer in stop-action photography. In 1931 he invented the stroboscopic flash, which gives off brilliant light for a microsecond, freezing action while rendering precise detail. Edgerton's work had a profound influence on the course of twentieth-century photography. His photographs changed the way we see the world, often transcending the limits of scientific documentation and passing into the realm of visual icon.

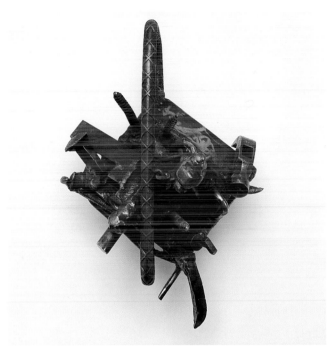

Kotoko
1994

Melvin Edwards

Born in Houston in 1937, Melvin Edwards studied at the Museum of Fine Arts, Houston, the Los Angeles City College and the Los Angeles County Art Institute (currently Otis Art Institute of Parsons School of Design), receiving his B.F.A from the University of Southern California in 1965. Since 1960, he has participated in numerous exhibitions in this U.S. and abroad, including the Santa Barbara Museum of Art, the Walker Art Center, Minneapolis, the Whitney Museum of American Art, as well as several traveling exhibitions, including a 30-year retrospective at the Neuberger Museum, State University of New York at Purchase in 1993. In addition to his sculptures, he has completed several public art projects and has collaborated with his wife and poet, Jayne Cortez, on a number of illustrated books. Edwards' emotive works derive meaning from their complex vocabulary, syncopated rhythms, and the associative interplay between the found objects he uses and their original functions. In 1963, during the Civil Rights Movement, he created his first "Lynch Fragment," now a series of over 200 wall-hung works. Inspired by African traditions and jazz and meant to generate a one-on-one experience, the series combines welded and stainless steel with found objects, including chains, spikes, railroad ties, and tools. At once brutally realistic and beautifully abstract, these sculptures suggest African masks while addressing personal, racial and cultural issues as well as the metalworking process, a deeply spiritual calling in African religion.

Near the River at Greenville, Miss. 1986

William Eggleston

William Eggleston was born in Memphis, Tennessee, in 1939. He attended Vanderbilt University in Nashville, Delta State College in Cleveland, Mississippi, and the University of Mississippi in Oxford. Considered a master of color realism, Eggleston established his reputation as a photographer with his first one-man show at the Museum of Modern Art, New York, in 1976 at the age of thirty-seven. Since then he has exhibited internationally, and has been widely published, including a portfolio of Graceland, the home of Elvis Presley, and a book, The Democratic Forest, a chronicle of the Western world from the Tennessee hills to the Berlin Wall. He is the recipient of numerous awards, including a Guggenheim Fellowship in 1974 and a National Endowment for the Arts Fellowship in 1995. In addition to his work in photography, Eggleston is an accomplished draftsman and painter. His work can be found in the collections of the Museum of Fine Arts in Houston, the Museum of Modern Art and the Whitney Museum of American Art in New York, and the National Gallery of Art in Washington, D.C. A "street" photographer in the tradition of Henri Lartigue, Walker Evans, Lee Friedlander, and Garry Winogrand, Eggleston seeks to capture the elusive moment, often with a lurid, unsettling twist. His largely unpopulated images focus on seemingly insignificant everyday scenes realized in vivid, saturated colors.

Old Handyman's Tea (2 views)
1993

Glenn Elvig

Born in Houston, Texas, in 1953, Glenn Elvig graduated in 1975 from the University of Minnesota with a B.S. in Education and Ceramics. After spending three years as a production potter and high school art teacher, he has pursued studio work for the last 23 years in the Minneapolis region of Minnesota. Inspired by the work of Claes Oldenburg, Ellsworth Kelly, and Gary Larson of "The Far Side," Elvig's sculpture and furniture design are whimsical hybrids of exquisite craftsmanship. Often they wittily exploit visual and literary cross-overs. His wall mirror *Arthur Fielder Meets Dean Martin*, for example, includes a conductor's baton skewered with three martini olives. The artist enjoys working in series, which allows him to "pull and stretch an idea." *Old Handyman's Tea* is part of the *Twenty-Six Tease* series, in which tea boxes correspond to the alphabet letters. For an artist who recognized his profession at age four, Elvig is now represented in numerous public and private collections, such as the Smithsonian Institution and the Louisville Slugger Museum, Kentucky. The recipient of several awards including the Bronze Medal at the London Woodworks Show in 1985, he has shown his work extensively throughout the U.S. and abroad.

Richard Estes

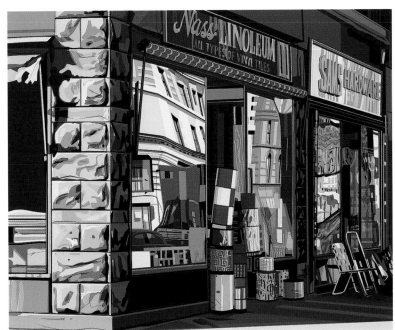

Nass Linoleum
1972

Richard Estes was born in Kewanee, Illinois, in 1932, and was raised in Evanston, Illinois. He studied at the Art Institute of Chicago and began his career as a commercial artist, working in publishing and advertising. In 1959 he moved to New York. He spent a year living and painting in Spain in 1962. Estes quickly rose to prominence as a seminal Photorealist. He had his first solo show in 1968 at the Allan Stone Gallery, New York, and has since participated in numerous national and international exhibitions. Known primarily as a painter, Estes is also an accomplished printmaker. His work can be found in collections of the Art Institute of Chicago, the Solomon R. Guggenheim Museum in New York, the Hirshhorn Museum and the Sculpture Garden in Washington, D.C., and the Teheran Museum of Contemporary Art, Iran. Estes' art, virtually synonymous with the urban streetscape, makes contemporary icons out of storefronts, parked vehicles, street furniture, and signage. Using photographs that he takes himself, Estes painstakingly records structural relationships until he achieves an idealized order devoid of decay and, for the most part, of human presence and emotion. A timeless, frozen quality transforms his scenes, mirroring the crisp edges and glittering surfaces of his highly finished canvases. Like Edward Hopper and Jan Vermeer – two of his heroes – light is central to his vision of the world. Estes' work is also marked by an allover focus that rewards extended viewing.

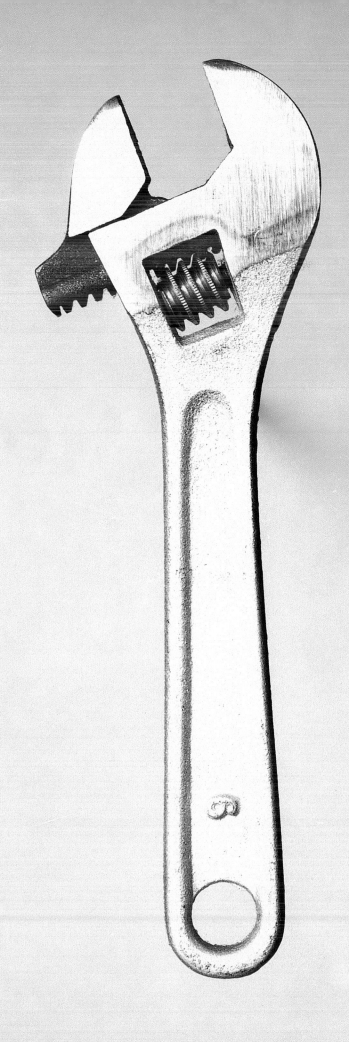

Walker Evans

Walker Evans was born in St. Louis, Missouri, in 1903 and was raised in Kenilworth, Illinois. After attending Williams College, he lived in Paris and took courses at the Sorbonne. He settled in New York in 1927 and started taking photographs the following year. His first photographs, of early Victorian houses in New England and New York, were exhibited at the Museum of Modern Art in New York in 1933. In 1935 he spent time in Mississippi and Alabama photographing tenant farmers and sharecroppers; these photographs were published in a collaborative book with the writer James Agee titled *Let Us Now Praise Famous Men* (1941). In 1945 Evans became a staff photographer and then an associate editor for Fortune magazine, where he worked until 1965. There he published many photographic portfolios, including "Beauties of the Common Tool" (July 1955), which he introduced by writing that "almost all basic small tools stand, aesthetically speaking, for elegance, candor and purity." After leaving the magazine, he became a professor of graphic design at Yale University, where he remained until his death in 1975. He received many awards, including a Guggenheim Foundation Fellowship in 1940. His work has been exhibited internationally, with a 2000 retrospective at the Metropolitan Museum of Art, New York, and a 2001 exhibition at the J. Paul Getty Museum, Los Angeles, and is included in most major museum collections of photography. Along with Berenice Abbott and Dorothea Lange, Evans established the tradition of documentary photography. He was profoundly affected by the social problems of his time and felt a sense of responsibility to point up the plight of the less fortunate. By striving to make his images as detached and unemotional as he could, by removing sentiment and beauty, Evans endowed these social commentaries with profound impact.

Women in Labor 1986

Henryk Fantazos

Henryk Fantazos was born in Kamionka Strumilowa, near Lvov in former Poland, in 1944. He attended the Lyceum of Fine Arts in Katowice, Poland, from 1957 to 1963, and completed an M.F.A. in painting at the Academy of Fine Arts in Cracow, Poland. He has been a professional painter since 1969, and has participated in exhibitions in the United States and Poland. His work is included in several public and private collections both in Europe and the United States. In 1975, he came to New York where he was granted political asylum. Subsequently he has lived in West Virginia and North Carolina. Vital to his art is the belief that modern art is a "worthless, dead-end barbarism." Instead, he draws on the traditions of the Neue Sachlichkeit Viennese School and the Cracow Circle of Metaphorical Art, creating haunting still lives and poetic commentaries on contemporary urban existence, often tinged with a dark humor.

Howard Finster

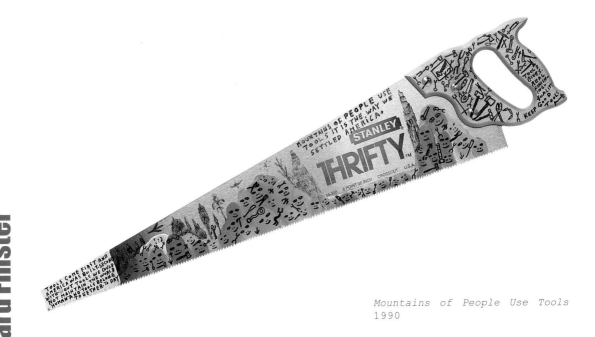

Mountains of People Use Tools
1990

Howard Finster was born in Valley Head, Alabama, in 1916, and lived at his three-acre home, called Paradise Garden, in Pennville, Georgia, from the mid-1960s until his death in 2000. From the age of three onward, he experienced visions and was a revivalist Baptist preacher for forty years in Georgia, Alabama, and Tennessee. He didn't receive, however, his calling to paint 'sacred art' until 1976, when he was retouching a bicycle and a splash of white paint on his finger transformed into a vision. Since then he created thousands of evangelically patriotic, religious, and heroic paintings and sculptures. Today he is recognized as the best-known folk artist of the twentieth century. His work has been exhibited widely, including shows at the High Museum of Art, in Atlanta, Georgia, the American Art Museum in Washington, D.C., the Museum of American Folk Art and the Paine-Webber Gallery in New York, and the Los Angeles County Museum of Art. In 1984 he was included in the United States exhibition at the Venice Biennale, and the Coca Cola Company commissioned him to paint an eight-foot Olympic Coke Bottle to represent the U.S. art exhibitions for the 1996 Olympics. His riotous images, which combine every kind of graphic medium, include 'primitive' portraits of such American icons as Elvis Presley, George Washington, and John Kennedy, as well as biblical quotations and texts from his own fiery wisdom. Tools held a particular fascination for Finster, who considered them the hallmark of civilization and the key to winning the American West.

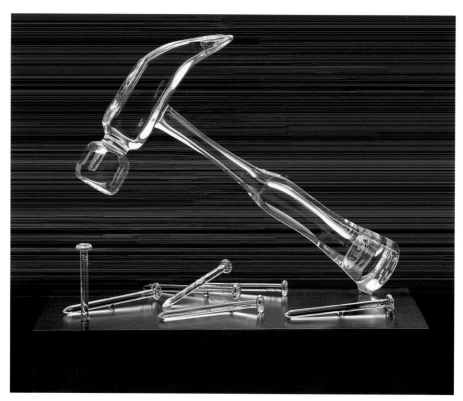

Hammer and Nails
1980

Hans Godo Fräbel

Hans Godo Fräbel was born in Jena, Germany, in 1941. He studied scientific glassblowing at Jena Glaswerke and took art classes at the Mainzer Kunstschule in Mainx, Germany. In 1965 he moved to Atlanta, Georgia, where he attended the Georgia Institute of Technology. In 1968 he established the Fräbel Studio in Atlanta. Today he is recognized as one of the world's leading glass artists. He has done commissions for Absolute Vodka, the Carter Center, the Corning Museum of Glass, and the Smithsonian Institution, among others. Fräbel's delicate and innovative sculptural compositions begin with heated borosilicate rods that are shaped with a hot lamp or by hands. His subjects, often rendered at life-size scale, encompass the human figure, tools, birds, flowers, and water droplets.

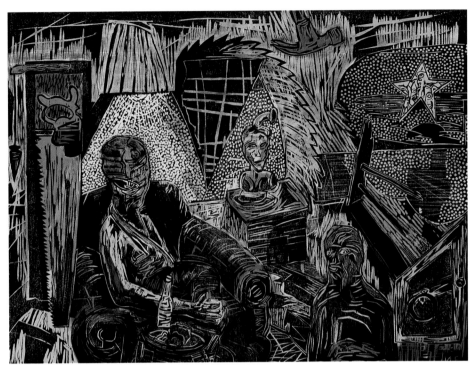

Tornado
1991

Ke Francis

Born in Memphis, Tennessee, in 1945, Ke Francis studied at the Memphis Academy of Arts from 1964 to 1967 and earned his B.F.A. from the Cleveland Institute of Art in 1969. Francis works in a variety of media, including painting, sculpture, printmaking (particularly woodcuts), and photography, and often combines several media in a single installation. He has been awarded a National Endowment for the Arts Individual Artists Grant and a Rockefeller Foundation Grant. His work has been exhibited at the Southeastern Center for Contemporary Art, Winston-Salem, North Carolina, and the National Museum of American Art, Washington, D.C. His profoundly narrative works seem to translate the Southern oral tradition into visual terms. In 1981 Francis began working on the "Reconstruction" series, which depicts the destruction wrought by tornados and the rebuilding that goes on afterward. His idiosyncratic style – part Cubist, part "primitive" – and his particular vocabulary of images, including the circular saw, combine to create quirky yet heroic paeans to the human spirit.

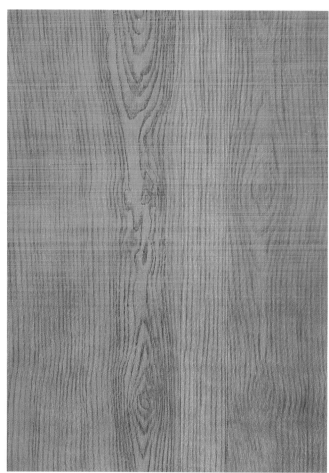

Untitled (Oak)
1990

Peter Gryzybowski

Peter Gryzybowski was born in Poland and received his artistic training at the Cracow Academy of Fine arts from 1977 to 1982. He moved to the United States soon after completing his degree. His work has been exhibited in Poland, France, Germany and the United States, and can be found in public and private collections in the U.S. and Poland. A painter as well as a performance artist, Gryzybowski is known for his trompe l'oeil images – including an ongoing series of paintings resembling wood panels. Nearly distinguishable from their actual counterparts, these visual conundrums pose a playful challenge to the viewer. In addition, he has created several multimedia and computer art projects.

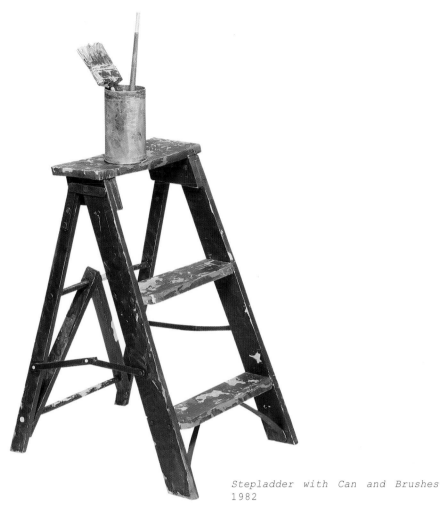

Stepladder with Can and Brushes
1982

Pier Gustafson

Pier Gustafson was born in Minneapolis, Minnesota, in 1956. He received a B.S. from Gustavus Adolphus College, St. Peter, Minnesota, in 1978, and an M.F.A. in painting from the University of Wisconsin at Madison in 1982. He then moved to Boston. Gustafson makes painstakingly folded paper constructions and then covers the surface with pen and ink, creating, in effect, three-dimensional drawings. He has received two Massachusetts Artist Fellowships and a National Endowment for the Arts Fellowship. His work has been exhibited at the Museum of Fine Arts, Boston, the Institute of Contemporary Art, Boston, the Minnesota Museum of Art, St, Paul, Museum of Art, Rhode Island School of Design, Providence, and the Weatherspoon Art Gallery, Greensboro, North Carolina, among others. He began making sculpture-drawings of individual objects such as paint tubes and hammers, and then went on to create whole environments, including a crowded garage and a storeroom filled with forgotten objects.

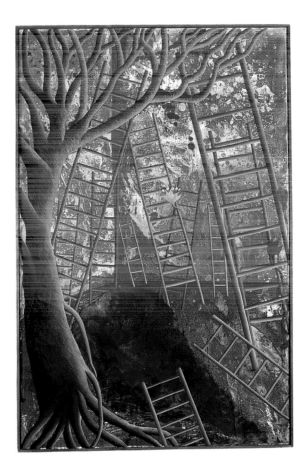

Zu Kafka's
Verwandlung
1994

HELMA

HELMA was born in Berlin in 1940, where she currently lives. Her deeply passionate and psychologically charged painting represents a search for self, inspired, at times, by the literature and poetry of Rainer Maria Rilke and Franz Kafka, among others. Referring to her work as "Voodoo, painted conjuration," she interweaves Old Master and faux-naïve techniques with bright color passages, at once warm and chilling in effect. Intricate, even, claustrophobic compositions result, which suggest the ambivalent visions seen in daydreams and nightmares. Images of ladders in an enclosed garden, a bleeding heart pierced by knives, networks or roots and blood vessels, and an immense coiling snake speak to the cycle of life and death and to the liberating power of transformation.

Watchtower
1995

Tracy Heneberger

Born in New London, Connecticut in 1954, Tracy Heneberger grew up in Brazil, and earned a B. A. in 1978 from New York University. His sculpture and drawing have been shown extensively in the U.S. as well as Norway and China. Since 1996, his work has shifted towards organic abstraction and reflects an increasing consideration of fragments in relation to larger forms. He continues to be fascinated by the humble yet wondrous design of commercial, mass-produced hardware. A corrugated nail or copper banding becomes the repeated building blocks within the restrictions of a rigorous geometry. Deeply poetic and richly textured, the finished works belie their industrial origins and their labor-intensive creation. Often they are inspired by poetry and autobiography. *Watchtower*, for example, is loosely drawn on the stooped figure of an elderly man that the artist could see from his studio window, while evoking a fortress or a lookout. More recently, he has experimented with single casting during foundries residencies in China, especially the ability of molten metal to unify an object while preserving characteristics of individual elements. The Japanese concept of *wabi*, or the beauty of subtle imperfections, pulses through these works, sometimes the results of chance, and at others, of choices made during the process. Here as elsewhere, a sense of life and grace emanates from their idiosyncratic forms.

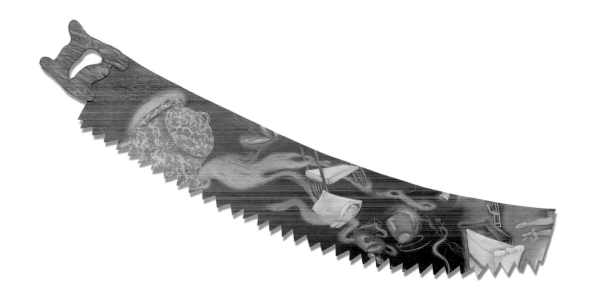

Dreamtime
1991

Lou Horner

Lou Horner was born in Nash-
ville, Tennessee, in 1954. She holds
a B.A. from George Peabody College
in Nashville. Her work has been
shown at the National Museum of
Women in the Arts in Washington,
D.C., the Charles A. Wustum Museum
in Racine, Wisconsin, and at galler-
ies in Tennessee. In the late 1980s,
Horner became intrigued with the
shape of saws, and has since pro-
duced paintings on wood cut into saw
shapes. Her figurative imagery rep-
resents a personal kaleidoscope of
the memories, desires, hopes, and
fears that result from everyday
experience.

Ben Jakober

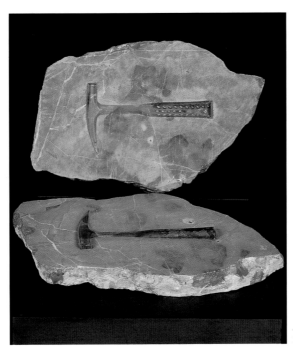

Anomalous Fossil No.2
1986

Born of a Hungarian family in Vienna in 1930, Ben Jakober became a British citizen in 1946, and has lived successively in Austria, England, France, Spain, Malta, and Mallorca. He first gained recognition in 1982 with "Slop Art," a series of ironic works inspired by the Surrealists. He then turned to bronze sculpture with the series "Archeology of the Present." In the clever *Anomalous Fossil No. 2*, for example, the two halves of the stone sculpture feature the carved negative and positive form of a hammer, the very tool used to split the stone. Other materials, including computer chips and engraved circuits, show up in subsequent work, while the drawings of Renaissance Masters contributed to several large-scale steel commissions. Beginning with *Cavallo di Leonardo*, which he made with his wife Yannick Vu for the 1993 Venice Biennale, the two have collaborated on several solo and group exhibitions throughout Europe and Venezuela, which address the interaction between the masculine and the feminine. That same year, he won the Pilar Juncosa & Sotheby's Special Prize by the Fundació Pilar i Joan Miró a Mallorca. For the last few years, they have also created several water sculptures and fountains as well as investigating the possibilities of fiber optics. Jakober's work and his collaborative projects can be found in numerous European collections, including the Museo National Centro de Arte Reina Sofia, Madrid and the Museum Moderner Kunst, Palais Liechtenstein, Vienna, and the Musco de Arte Contemporánco, Barcelona, among others.

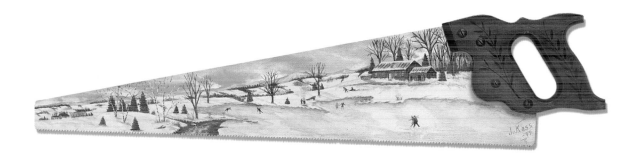

Untitled
1981

Jacob J. Kass

Jacob Kass was born in Brooklyn in 1910 and died in 2000. From 1922 until his retirement in 1972, he worked in his father's firm, which specialized in painting commercial signs on the sides of trucks—images of everything from bridges to beer. Upon his retirement he divided his time between Florida and Vermont, where he began to paint frying pans, wood scoops and oil and milk cans that he bought at local auctions and yard sales. In 1977, taking up a venerable folk art tradition, he began painting landscapes and busy cityscapes of Old New York on antique saws. Since 1981, when the Allan Stone Gallery in New York gave Kass his first show, he has had exhibitions at the Lowe Art Museum, University of Miami, and the Tampa Museum of Art, Florida, the South-eastern Center for Cotemporary Art, the Federal Reserve, Washington, D.C., and a 2002 retrospective at the American Folk Art Museum, New York. Kass has also received a National Endowment of the Arts Fellowship. Now encompassing over 250 examples, the works counterpoint the roughness of the tool with the wholesomeness of the painting, as well as the saw's given, simple geometric shape with the complex miniature world it portrays. At the same time, his bucolic panoramas are imbued with a simple nostalgic charm that complements the age of the saw blades.

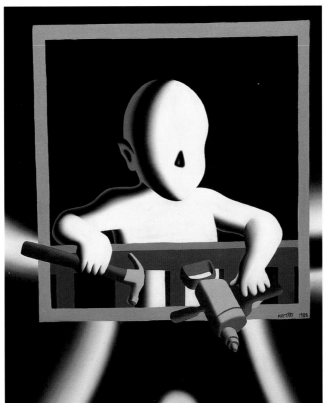

Power Tool Baby
1989

Mark Kostabi

Mark Kostabi was born in Los Angeles in 1960 and grew up in Whittier, California. After studying at California State University at Fullerton from 1978 to 1981, he moved to New York City in 1982. Kostabi had his first New York exhibition at Ronald Feldman Gallery in 1986 and has exhibited internationally since, including shows at the Metropolitan Museum of Art and the Museum of Modern Art, New York, and the Mitsukoshi Museum in Tokyo. All of his work, which is primarily painting, is created at his "factory" in Brooklyn, known as Kostabi World, where he employs artists to design and paint images that he then signs. He is known for faceless "Everyman" figures, which he places in simply depicted settings. Often emitting a sense of ironic alienation, his work includes historical references and images from earlier periods of art.

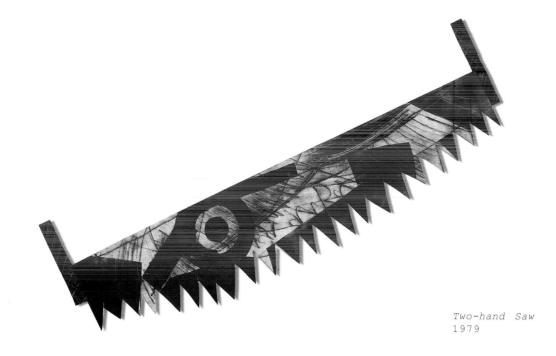

Two-hand Saw
1979

Oleg Kudryashov was born in Moscow in 1932. He attended the Moscow State Art Studios in 1942-47 and the Moscow Art School in 1950-51. In 1974 he emigrated to London, where he lived until returning to Moscow in 1998. Kudryashov has exhibited extensively in the U.S. and Europe, including shows at the Institute of Contemporary Art, University of Pennsylvania, Philadelphia, Duke University, Durham, North Carolina, the Tretyakov Gallery, Moscow and the Pushkin Museum, Moscow. His work is included in the collections of the Pushkin Museum, Moscow, the Tate Gallery, London, the National Gallery of Art, Washington D.C., and the Hirshhorn Museum and Sculpture Garden, Washington D.C. Kudryashov works primarily in the medium of drypoint etching, a technique favored by seventeenth-century Dutch masters. The artist draws expansively with a burin, a printmaking tool, directly onto a zinc plate. He then prints these "drawings" on paper on which he has already worked free-form style with a variety of media, including gouache, watercolor, and charcoal. In the late 1970s he began to cut three-dimensional artworks that blur the lines between drawing, sculpture, and printmaking. The combination of hard-edged geometric forms with painterly abstraction points to the influence of early-twentieth-century Russian Constructivism and Cubism, as well as the Abstract Expressionism of New York in the 1950s. Among the recurring references in his work is a broken saw, which has been said to find its roots in childhood experiences in the freezing Russian winters.

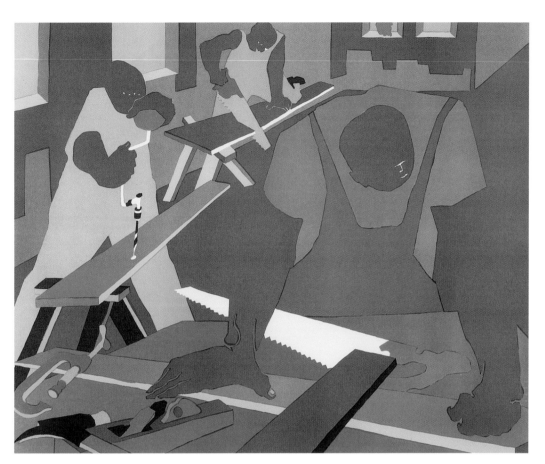

Carpenters
1977

Jacob Lawrence

Jacob Lawrence was born in At-
lantic City, New Jersey, in 1917,
and died in Seattle, Washington, in
2000. He moved with his family to
Easton, Pennsylvania, and to Phila-
delphia before settling in Harlem,
New York, in 1931, when he began
studying with the painter Charles
Alson at the WPA Harlem Art Work-
shop. In 1936 he was awarded a
scholarship to the American Artists'
School in New York City, and in 1938
he was hired by the WPA Federal Art
Project. During this period he began
his best-known series, "The Migra-
tion", which he completed in 1941.
Consisting of sixty panels with
accompanying texts, the series de-
picts the movement of African-Ameri-
cans from the farms and rural commu-

nities of the South to the industrial cities of the North after World War I. " The Migration" was exhibited at the Downtown Gallery, New York, and was purchased by the Museum of Modern Art, New York, and the Phillips Collection, Washington, D.C. In 1943 Lawrence was drafted into the Coast Guard. He was awarded a Guggenheim Foundation Fellowship in 1946; that same year he produced the "War" series. In 1947 Fortune Magazine commissioned him to paint a series of ten images of the South after World War II, for which Walker Evans wrote an accompanying text. Lawrence revisited the migration theme in a series of illustrations he did for a book of poetry by Langston Hughes, *One-Way Ticket*. Lawrence, who has been described as a painter of the American scene, an American modernist, and a social realist, was given his first retrospective at the Brooklyn Museum in 1960, and has since had numerous exhibitions around the world, including two U.S. traveling exhibitions in 1998-2000 and in 2001-2203. This chronicler of American life began his most recent series, "Builders," in the mid-1970s. In addition to his paintings and works on paper, Lawrence completed several commissioned murals, including one for the Times Square Subway Complex, New York, New York.

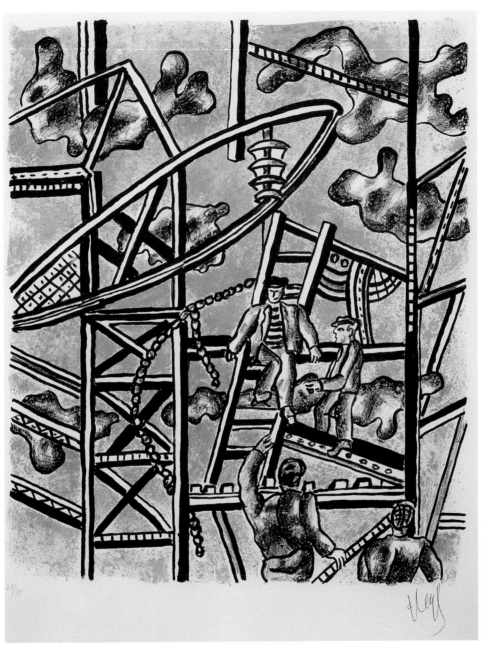

Les Constructeurs
1951

Fernand Léger

Fernand Léger was born in Argentan in France, in 1881 and died in Grif-sur-Yvette, France, in 1955. One of the great masters of the twentieth century, Léger continues to exert a lasting influence on generations of younger artists. After being apprenticed to an architect in Caen from 1897 to 1899, Léger worked as an architectural draftsman in Paris from 1900 to 1902. He spent the next year in

military service. Although he was refused regular admission at the Ecole des Beaux-Arts in Paris, in 1903 he took classes there, as well as studying art in Jean-Léon Gérome's studio at the Académie Julian. The 1907 Cezanne retrospective had a powerful effect on Léger, contributing to his nascent interest in light and in manufactured objects. By 1910 he had met most of the Parisian avant-garde and had joined Robert Delaunay, Albert Geizes, and others in the creation of the La Section d'Or group of Cubist artists. The following year he exhibited in the Salon des Indépendants in Paris. Léger's version of Cubism emphasized bold designs of primary, tonal colors and streamlined forms suggestive of machines. His frightening experience in World War I prompted a return to a more concrete subject matter and a stricter formal order that was a contrast to the chaos of human life and the vicissitudes of nature. Along with members of De Stijl and the Purist movements, he envisioned a positive social function for art. Léger called his metallic style the "new realism" because it reduced all forms, including the human body, into machine-like images. At the same time, he endowed his everyday, quasi-cartoonish figures with a heroic sense. An extremely versatile artist, he also worked as an illustrator and set designer. In the 1930s and 1940s he exhibited at the Museum of Modern Art, the Art Institute of Chicago, the San Francisco Museum of Art, and the Fogg Art Museum, Cambridge, Massachusetts. Following his return to France, he had exhibitions at the Musée National d'Art Moderne and the Tate Gallery, London. He became involved in numerous large-scale projects, creating murals and stained-glass windows for secular and religious buildings. He also turned his artistic energies increasingly to ceramics, mosaics, and sculpture, addressing the themes of peace and love. Since his death, he has been the subject of numerous exhibitions worldwide, including a 1997-1998 traveling retrospective on view at the Centre Georges Pompidou, Paris, Museo National Centro de Arte Reina Sofia, Madrid, and the Museum of Modern Art, New York.

Donald Lipski

Born in Chicago, Illinois, in 1947, Donald Lipski earned a B.A. in 1970 from the University of Wisconsin, Madison, and an M.F.A. in 1973 from Cranbrook Academy of Art, Bloomfield Hills, Michigan. He has participated in numerous solo and group exhibitions throughout the U.S. as well as in Europe and Japan, including the Museum of Modern Art, New York, the South Eastern Center for Contemporary Arts, Winston-Salem, Madison Art Center, Wisconsin, and the Contemporary Arts Center, Cincinnati. He has received several commissions and awards, and his work is in private and public collections worldwide, including the Whitney Museum of American Art and the Museum of Modern Art, New York. Lipski has turned his protean energies to recycling bells, books, razor blades, and shoes, as well as such icons as the American flag, which he has used as a wrapping device. In the Water Lilies series,

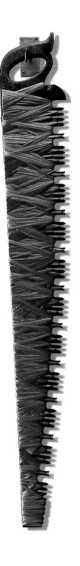

Untitled
1994

for example, grasses and plants encased in Corning evacuation pipes and boiling flasks address issues of growth and preservation. In addition to transforming often mass-produced discards, he has coaxed new objects out of prosaic materials, such as a pair of high heels from a dissecting tray, wax, rubber soles and steel balls in *Building Steam No. 431*. In the tradition of Surrealism and Dada, his sculpture revel in the improbable, overturning expectations with witty juxtapositions and a boundless sense of play.

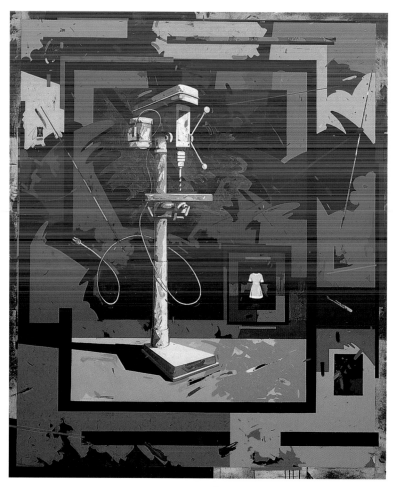

Homage to the Industrial
Revolution #2 - Drill Press
1986

Mark McDowell

Mark McDowell was born in Pennsylvania in 1954. He earned a B.F.A. in drawing and printmaking from Pennsylvania State University and did graduate work at Arizona State University. McDowell has shown his paintings and prints throughout the United States, particularly in the Southwest, including the Tucson Art Institute and the Scottsdale Center for the Arts. In 1983 he received a fellowship in printmaking from the Arizona Commission on the Arts. His works can be found in the collections of the Chase Manhattan Bank and the University of New Mexico. In the mid-1980s McDowell began a series of paintings on the Industrial Revolution in America as a kind of homage to tools "that make our lives on this planet a bit easier".

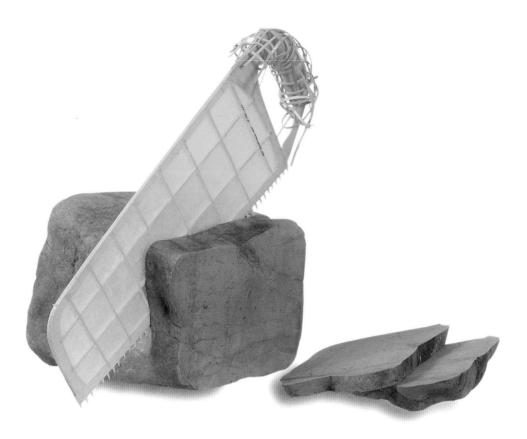

Zen Saw II
1986

John Mansfield

Born in 1943 in Milton-Freewater, Oregon, John Mansfield spent his formative years in Japan and various parts of the United States, including Hawaii. He earned his B.F.A. in 1966 from the College of Arts and Crafts, Oakland, California, and his M.F.A. in 1970 from the University of Oregon. In 1973, after a long hiatus, Mansfield returned to making art while living in Colorado. He has since exhibited on the West Coast and the Southwest.

Mansfield's sculptures focus on the relationship between Eastern and Western cultures, exploring the differences in the way each culture visually represents the world. Often he presents conundrums intended to trigger a new awareness without resorting to rational thinking. Mansfield reinforces the differences by contrasting traditional Eastern and Western materials within his artworks.

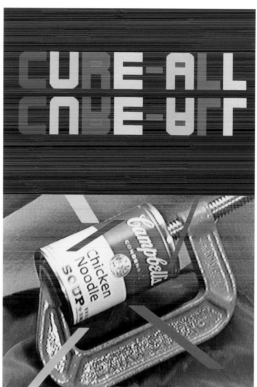

Cure All
1984

MANUAL

MANUAL is the *nom d'artiste* for husband-and-wife photographers Edward Hill and Suzanne Bloom. Edward Hill was born in Springfield, Massachusetts, in 1935. He received a B.F.A. from the Rhode Island School of Design, Providence, in 1957 and a M.F.A. from Yale University in 1960. Suzanne Bloom was born in Philadelphia in 1943. She earned her B.F.A. from the Pennsylvania Academy of Fine Arts, Philadelphia, in 1965 and her M.F.A. from the University of Pennsylvania in 1968. MANUAL's work has been widely exhibited in museums and galleries throughout the United States, including the Museum of Contemporary Photography, Chicago, Contemporary Arts Museum and the Museum of Fine Arts, Houston, and a retrospective at the International Center of Photography, New, as well as in Korea, Ecuador, France, Germany, Denmark, Italy, and Scotland. The two have collaborated since 1974, creating manipulated photographs, videos, and installations. Over the years, they continue to mine the shifting, often difficult relation between nature, culture and technology, which often feature puns and allegories. In the 1980s, they produced a series of photographs that explores pop-culture icons. Recently, they have begun to address environmental issues in a series of computer-generated photographs, and in 1997, they established, and now manage the Internet Web site for digital imaging (www.art.uh.edu/dif).

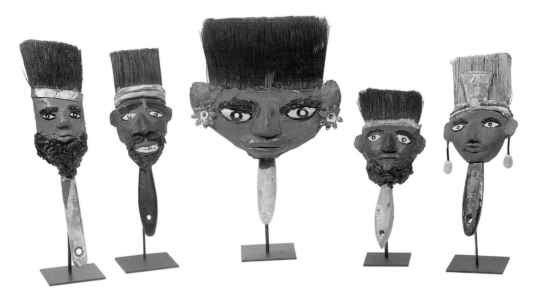

Paintbrush Portraits
1991

Mr. Imagination

Mr. Imagination was born in 1948 and has lived most of his life in Chicago. Although he has no formal artistic training, he has always been creatively inclined. In 1978, while in a coma after being critically wounded by gunshot, he had visions of himself as an Egyptian pharaoh; these images inspired the work he began creating during his recovery. He also draws on Christianity, contemporary events, and public figures as sources for his imagery, and he often incorporates African patterns and motifs into his work. The artist begins with found objects and materials, which he carves and paints using simple tools, often other found objects that have lost their original usefulness. The paintbrush portraits, a continuing series, grew out of his reluctance to discard the brush he had used to create his early works. Having grown attached to it, he said, "Finally, I thought of this idea of bringing it back to life in another way." His work has been shown at the University of Illinois, Chicago, the Virginia Museum of Fine Arts, Richmond, the High Museum, Atlanta, and the Milwaukee Art Museum, Wisconsin, among others.

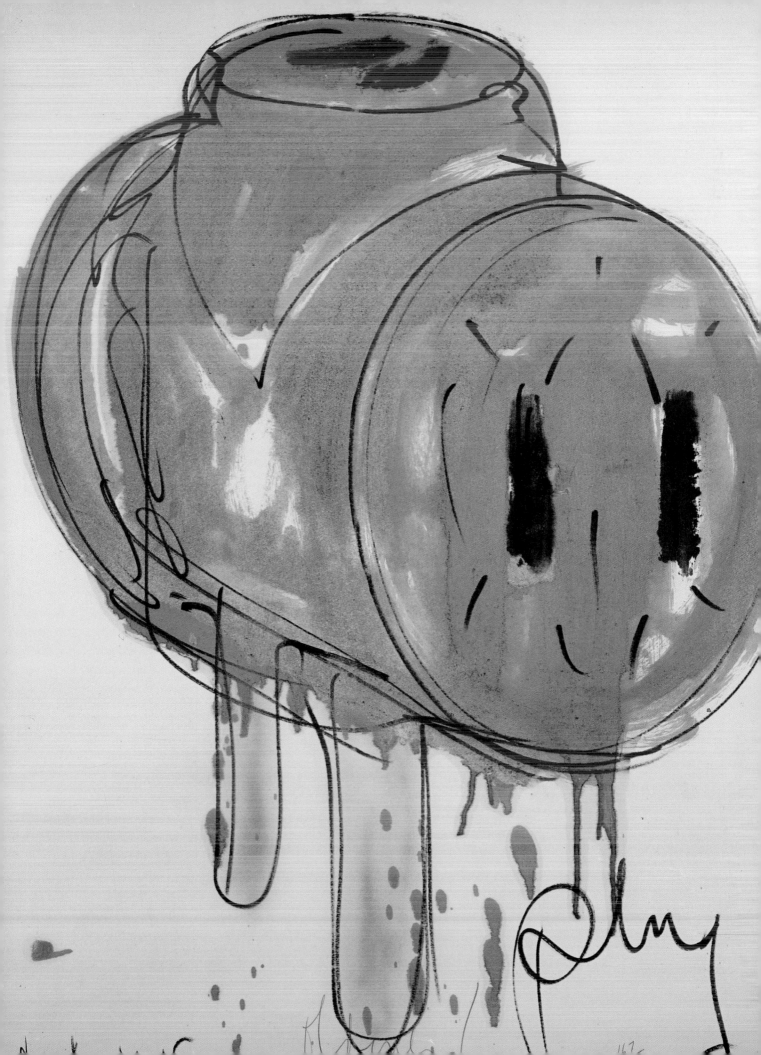

Claes Oldenburg

The son of a diplomat, Claes Oldenburg was born in Stockholm, Sweden, in 1929. He was raised in Chicago, becoming a naturalized American in 1953. A master of transformation, Oldenburg is considered the classic Pop artist, garnering attention for both his soft sculptures and his large-scale public projects based on everyday objects. Oldenburg received his B.A. from Yale University in 1950. He then worked in Chicago as a newspaper reporter while studying at the Art Institute of Chicago from 1952 to 1954. In 1956 he moved to New York, where he and his wife—and frequent collaborator—Coosje van Bruggen currently reside. Initially interested in drawing and painting, he became involved with downtown "happenings" and environmental artworks. In 1959 he had his first show at the Judson Gallery, along with Jim Dine. The following year he concentrated on drawing store goods and incorporating used consumer goods in his art. His handmade objects were sold in The Store and the Ray Gun Manufacturing Company, both part of his studio shop on East Second Street, from 1961 to 1962. The first of his signature oversize soft sculptures appeared in 1963 for his "theater of objects." Starting with his "Proposed Colossal Monuments" in 1965, he produced plans for city sculptures of quotidian objects that combine humor with a serious, often political edge. Over thirty have been realized as large-scale public monuments; the giant *Lipstick*, for example, was installed at Yale University. Since 1970 his work has been exhibited throughout the United States and Europe, including shows at the Philadelphia Museum of Art, the Whitney Museum of American Art and the Metropolitan Museum of Art, New York, the National Gallery of Art in Washington, D.C., and the Tate Gallery in London. In recent years Oldenburg has returned to soft fabric sculpture and continues his long-standing relationship with Gemini G.E.L. in printmaking and cast sculpture. In 1994 he received the Lifetime Achievement Award from the International Sculpture Center.

Tom Otterness

Hand and Hammer
1993

Tom Otterness was born in 1952 in Wichita, Kansas. He studied at the Arts Students League, New York, followed an independent Study Program at the Whitney Museum of American Art, NY, and is a founding member of Collaborative Projects Inc., New York. An accomplished sculptor and draftsman, Otterness is best known for his cartoonish animal and human miniatures in cast plaster and metal. Set into whimsical worlds, these plump and mischievous characters engage in various activities, while remaining oblivious to the viewer's gaze. Though thoroughly entertain, they also offer revealing commentary on human foibles and societal ills. His work has been shown in Europe and in the U.S. at the Museum of Modern Art, the Guggenheim Museum, the Brooklyn Museum, and the Krannert Art Museum, Illinois, among others, and is in numerous private and public collections, including the Corcoran Gallery of Art, Museum of Modern Art, the Guggenheim Museum, the Brooklyn Museum, among others. He is also the recipient of several major public art projects, including *Life Underground* for the NY Transit Authority. Inspired by 19th century political cartoons, the subway project encompasses a cast of some 130 figures. One vignette presents a white-collar worker being caught for farebeating. The installation's other distinguishing factor is that it can be touched. As the artist explains, "It's kind of democratic…you can really see what areas are the favorites by how shiny they are."

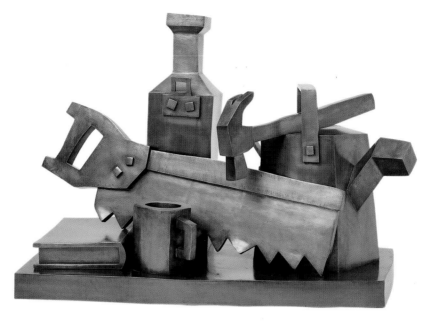

Still Life with Tenon Saw, 1985

Left: Cut, 1986

Christopher Plowman

Christopher Plowman was born in Hampshire, England, in 1952. He received a diploma in art and design from Wolverhampton Polytechnic in Wolverhampton, England, in 1973, and an M.A. from the Royal College of Art, London, in 1976. His work has been exhibited in Europe and the United States and is in the collection of the Tate Gallery and the Victoria and Albert Museum, London, the Arts Council of Great Britain, and the New York Public Library. He has taught in Britain and at the University of Houston, Texas. Plowman works in a variety of media, including sculpture, drawing, and printmaking, and he has won many awards. In the 1980s he produced an extensive series of still-life sculptures and prints about tools. In many of the prints, Plowman uses the objects to define the pictorial space, filling the compositions so the image expands visually into the viewer's space, thereby calling to mind a jumble of tools in an overflowing toolbox.

Self-Portrait in the Bathtub
1981

Clayton Pond

Born in 1941 on Long Island, New York, Clayton Pond received a B.F.A. from Carnegie-Mellon University, Pittsburgh, in 1961 and an M.F.A. from the Pratt Institute, Brooklyn, in 1966. His work has been exhibited at the Whitney Museum of American Art, New York, the Museum of Modern Art, Mexico City, and the Delaware Museum of Art, Wilmington. His work is included in the collections of the Museum of Modern Art, New York, the Los Angeles County Museum of Art, and the Art Institute of Chicago. A second-generation Pop artist, Pond uses a high-energy palette in his paintings and his prints, often outlining his objects in contrasting colors. His abiding interest lies in recording the obsessions and possessions of Americans. His early prints were close-up depictions of domestic objects such as toasters, telephones, and toilet seats; a later series involved leisure activities, humorously depicting people golfing and skiing. His most recent pieces are large-scale constructions of high-tech machines and printing presses.

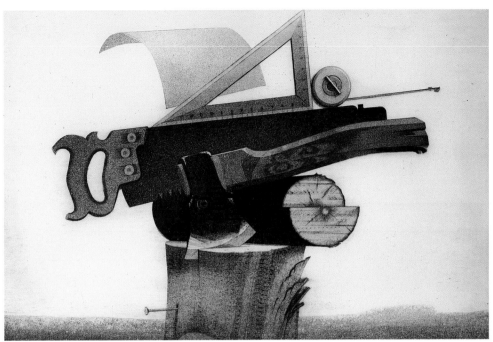

Saw and Axe
1987

Kaisa Puustak

Kaisa Puustak was born Tallinn, Estonia in 1945. She graduated from the Estonian Academy of Art in 1963, where she currently teaches. She is a member of the Estonian Artists' Association and the Estonian Printmakers' Association. An accomplished printmaker, she has had solo exhibitions in Tallinn, Estonia, Stockholm, Sweden, and Turku, Finland, and has participated in several international biennials. Her work can be found in private and public collections throughout Europe, the U.S., and Australia, including the State Tretyakov and the Pushkin Museum, Moscow, Ludwig Museum, Cologne, the Art Museums of Tallinn and Tartu, Estonia, and the University of New Orleans, among others.

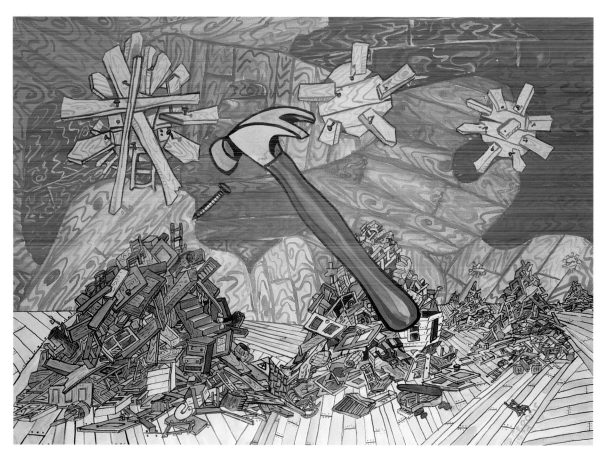

I Nailed Wooden Suns to Wooden Skies
1972

Red Grooms

Red Grooms was born Charles Rogers Grooms in Nashville, Tennessee, in 1937. An innovative painter, printmaker, filmmaker, and pioneer of "happenings," Grooms uses fantasy, wit and satire as ways to comment on modern life in America, especially the city and its inhabitants. He began drawing as a child, absorbing various influences that would later inform his art—Hollywood movies, the circus, and the Tennessee State Fair. In 1955 he enrolled at the School of the Art Institute of Chicago, but he quit after a semester. The following year he moved to New York and attended the New School for Social Research, where he studied under the social realist painter Gregorio Prestopino. He continued his formal training at the George Peabody College for

Teachers in Nashville, finishing at the Hans Hofmann School of Fine Arts in Provincetown, Massachusetts, in 1957. While working as a dishwasher in Provincetown that summer, the artist was nicknamed "Red" by a co-worker. In September 1957 he settled in New York and began to participate in "happenings" with Allan Kaprow and others. His early paintings were mostly figure studies and portraits painted with inexpensive hardware-store enamels and tinting colors. In 1958 he had his first exhibition, at the Sun Gallery in Provincetown, and a show at the City Gallery in New York later that year. Within a few years he was increasingly involved in making sculpture and collage. In 1962 he created his first film, Shoot the Moon, which was followed by several others, including the well-known Ruckus Manhattan (1975-76), a "sculpto-pictorama" of New York City, and Hippodrome Hardware (1972-73). Done as a circus-style show based on a live performance of the same name, Hippodrome Hardware pays homage to the tools of the trade employed in the Hippodrome, Manhattan's biggest theater. In the 1960s and early 1970s Grooms developed an exaggerated, cartoon-like style, which was heightened with the use of bright, high-keyed colors, bold compositions, and everyday subjects. This approach was also evident in his multimedia environments, in which he filled entire rooms with cutout figures and objects. In the late 1970s he turned his attention to diverse topics ranging from sex, football, and hardware to cowboy imagery. Today he continues to explore themes related to popular culture, striking an edgy balance between documentation and acerbic commentary. His work has been the subject of numerous exhibitions, including a retrospective at Rutgers University Art Gallery in New Brunswick, New Jersey, in 1973 and the Pennsylvania Academy of Fine Arts in Philadelphia in 1985, both of which subsequently traveled around the country, as well as a 2000 exhibition at the Contemporary Art Center in Virginia Beach. Groom is represented in leading public collections worldwide.

Siamese Hammer Joined
at the Handle
1982

Vladimir Salamun

Vladimir Salamun was born in New York City in 1942. In 1963 he earned a B.A. from Rutgers University in New Brunswick, New Jersey. He studied with Nicholas Carrone in 1964-65 and with George Spaventa at the New York Studio School in 1965-67. He received an M.F.A. from the Pratt Institute in 1976. In the last several years, Salamun has focused on the hammer as the subject of his Neo-Dadaist sculptures, which often recall the work of H.C. Westermann. Using assemblage techniques, he meticulously crafts them out of carved stone, wood, and cast metal. Some are oversize visual puns, while others are tongue-in-cheek portraits of art-world figures like Salvador Dali and Julian Schnabel.

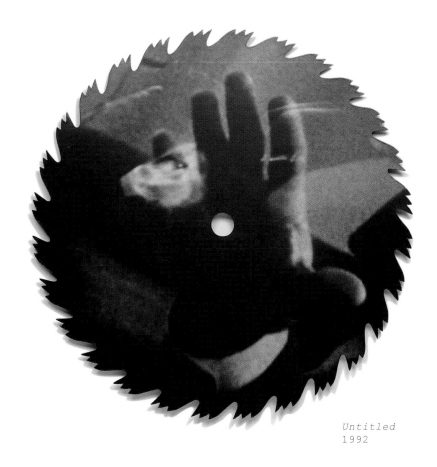

Untitled
1992

John Schlesinger

Born in New York City in 1955, John Schlesinger holds a B.S. in art education and a B.A. in philosophy and photography from the University of Minnesota in Minneapolis. He has received several awards, including two National Endowment for the Arts Fellowships. He has exhibited throughout the United States, The Netherlands, Scotland, Germany, and France. In the Surrealist tradition, Schlesinger draws on film and television, as well as staged and random elements from everyday life, to construct multi-layered, dream-like images that address issues of alienation from self and society. Surrounded with areas of darkness, his forms seem to float freely in space, lending an unsettling presence. In 1991 Schlesinger began a series of mostly figurative photographs mounted on circular saw blades that exploit the constructive and destructive qualities of the implement.

Crosscut Saw
1982
Opposite: *Rake Back Chair #2*
1981

Lee A. Schuette

Lee A. Schuette was born in Berlin, New Hampshire, in 1951. In 1971 he apprenticed with Jack O'Leary at Tariki Stoneware in Meriden, New Hampshire. The following year he attended the Pilchuck Glass School in Stanwood, Washington. He received a B.F.A. from the University of New Hampshire in Durham and an M.F.A. in industrial design from the Rhode Island School of Design, Providence. For the next three years he taught at the Wendell Castle Workshop in Scottsville, New York. A recipient of several awards, Schuette has been an instructor and an architectural designer in addition to a creator of highly innovative sculpture and furniture. His work has been exhibited at the Southeastern Center for Contemporary Art in Winston-Salem, North Carolina, the Museum of Contemporary Crafts in New York, the Rhode Island School of Design, and the Renwick Gallery in Washington, D.C. Drawing directly from nature and everyday life, Schuette challenges conventional ideas of furniture and materiality in his whimsical, masterfully crafted works.

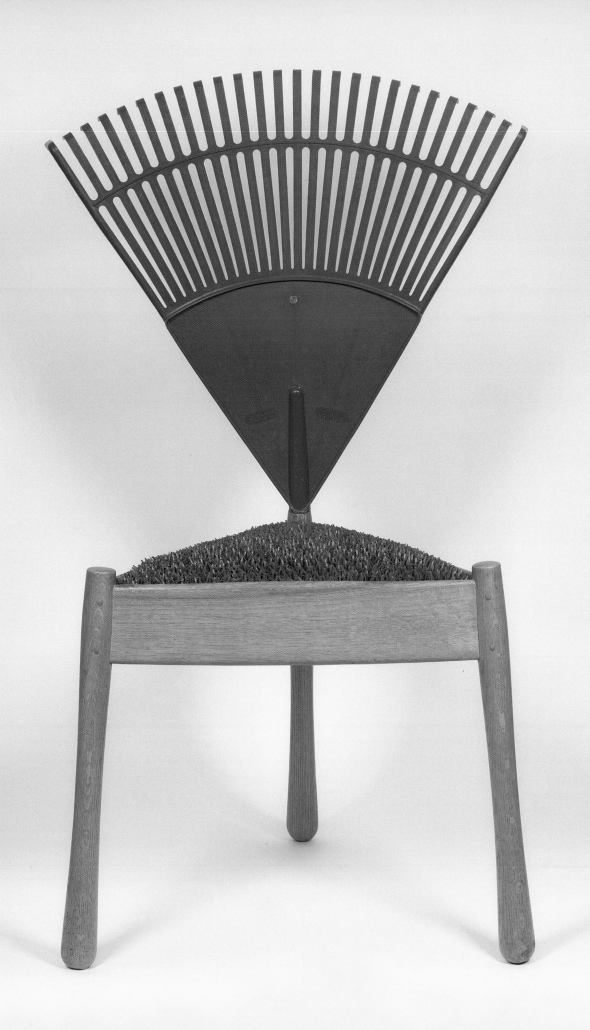

Roger Shimomura

Roger Shimomura was born in Seattle, Washington in 1939. He received his B.A. in graphic design from the University of Washington, Seattle, in 1961. He continued his studies at the Cornish School of Applied Arts in Seattle, Stanford University before earning a M.F.A. in 1969 from Syracuse University. A recipient of numerous fellowships and grants, his work is in the collections of the Denver Art Museum, the Alberta College of Art, Canada, and the Spencer Museum of Art, Lawrence, Kansas, among others. Since 1965, he has exhibited his paintings and prints extensively throughout the U.S., including the Indianapolis Museum of Art, Indiana, the Japanese American National Museum in Los Angeles, the Spencer Museum of Art, University of Kansas, and the American Art Museum, Washington, D.C., as well as a group exhibition at the Setagaya Museum in Japan in 1997. In addition, he has participated in solo traveling exhibitions in 1998,1996,1992, 1984, and 1979, and 30-year print retrospectives in 1998 and 1997. He has also had a distinguished career and written, directed, and produced a number of performances. In his multi-layered, action-packed paintings, which are rendered in flat, bright colors, politics are combined with *ukiyo-e* imagery, pop-culture clichés, and everyday consumer products. The resulting juxtapositions reflect his own personal history as a third-generation Japanese-American as well as addressing the broader social and cultural conflicts between the two countries.

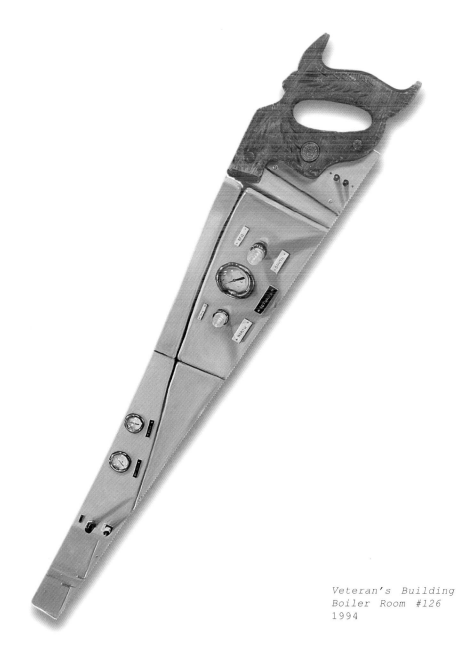

*Veteran's Building
Boiler Room #126
1994*

Rico Solinas

Rico Solinas was born in Oakland, California, in 1954. After studying at the Corcoran School of Art, Washington, D.C. from 1970 to 1972, he received his B.A. in art from the University of California at Santa Barbara in 1977 and an M.F.A. from the San Francisco Art Institute in 1988. Solina's figurative and landscape paintings and prints have been exhibited in Ecuador, Mexico, and California. In 1988 and 1989 he painted a series of landscapes with trucks on saw blades, playing against the bucolic images most often associated with the genre of saw paintings.

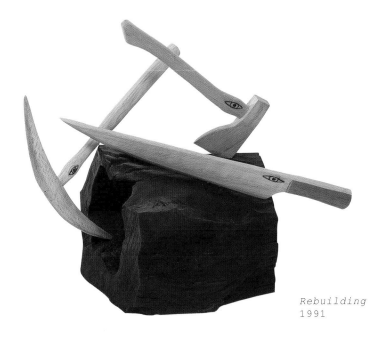

Rebuilding
1991

James Surls

James Surls was born in Terrell, Texas, in 1943. He holds a B.S. from Sam Houston State College in Huntsville, Texas. He studied with Julius Schmidt at Cranbrook Academy of Art in Bloomfield Hills, Michigan, where he received an M.F.A. in 1969. Since catching the eye of the art world in the 1970s with his tree-creature sculptures, which combined folk-art traditions with surrealist overtones, Surls has become recognized as a leading contemporary sculptor and has had numerous museum exhibitions throughout the United States, including The Contemporary Museum, Honolulu, the Cranbrook Academy Art Museum, Bloomfield, Michigan, and the Contemporary Arts Museum, Houston, as well as a 1984 exhibition that traveled to the Dallas Museum of Art, the La Jolla Museum of Contemporary Art, the Seattle Art Museum, and the University of Oklahoma Art Museum, Norman. He received a National Endowment for the Arts Fellowship in 1979 and was honored as the Texas Artist of the Year in 1991. His work can be found in the collections of the Stedelijk Museum in Amsterdam, the Seattle Art Museum, the Museum of Modern Art in New York, and the Dallas Museum of Art. Surls draws on formative childhood experiences in his highly expressive work, which he sees as a form of self-portraiture. Manipulating various native woods with hand and power tools, Surls creates fetishistic, anthropomorphizing imagery that celebrates the forces of nature and is inspired in part by Southwest Native American and Mexican cultures. Various symbols such as the spiral, the house, and the eye recur in his work, which addresses personal growth, gender relations, and the cosmos. Lately he has collaborated with poet Robert Creeley on series of prints that combines poems and images.

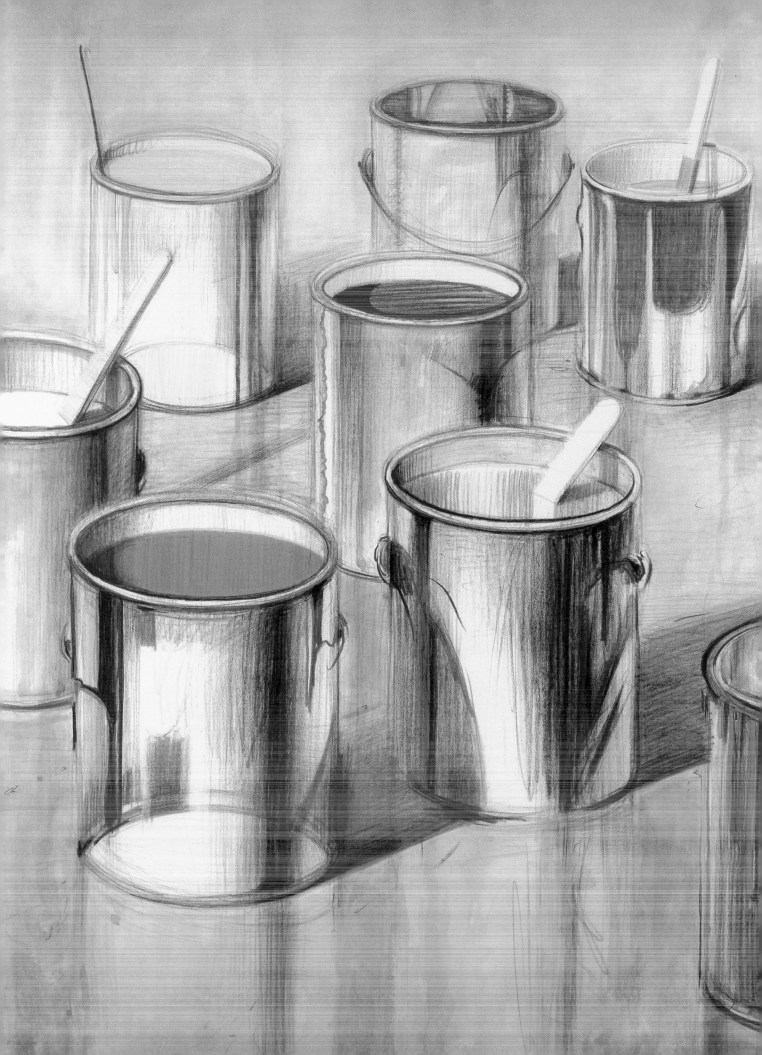

Wayne Thiebaud

Wayne Thiebaud was born in Mesa, Arizona, in 1920 and was raised in Long Beach, California. From the mid-1930s through the late 1940s he pursued a career as a cartoonist, an illustrator, and a muralist, and held a position at the Disney studios for a year until he decided to become a painter in 1949. He enrolled at California State College, receiving a B.A. in 1951 and an M.A. in 1953. In 1951 he had his first exhibition of paintings, at the Crocker Art Gallery. That same year he began a long teaching career, which has included positions at several colleges and art schools throughout the United States. In 1954 he established his own company to produce educational art films. Thiebaud's big break came in 1956-57, when he lived in New York and met de Kooning, Franz Klein, Barnett Newman, and Philip Pearlstein. Allan Stone gave him his first New York show in 1962, and Thiebaud went on to gain notoriety in the 1960s for his paintings of pies and other all-American foodstuffs, rendered in bold colors and a lavish impasto technique. Beginning with an exhibition at the Pasadena Art Museum in 1968, his work has been the subject of several major exhibitions, including a 2001 print exhibition at the Corcoran Gallery of Art, Washington, D.C., and touring shows at the Whitney Museum of American Art, New York, the Phoenix Art Museum, the Phillips Collection, Washington, D.C., the Fine Arts Museums of San Francisco, Palace of the Legion of Honor, and the San Francisco Museum of Modern Art. In 2001, he received the Lifetime Achievement Award for Art from the American Academy of Design, New York. Thiebaud has also pursued an interest in printmaking, and in 1983 he traveled to Japan to work with traditional woodblock printers. Although often associated with Pop Art and the work of Bay Area artists Richard Diebenkorn and David Park, Thiebaud's distinctive still lifes, as well as his figure compositions and landscapes, are more akin to Impressionism filtered through the paintings of Edward Hopper. Light dominates and unifies Thiebaud's oeuvre: vibrant, palpable shadows are as important as the harshly lit forms of his objects, which include neckties, shoes, and paint cans.

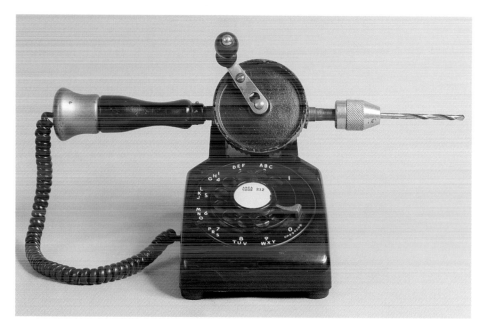

Drill-a-Phone
1990/1997

Richard Tipping

Born in Adelaide, South Austra-
lia, in 1949, Richard Tipping holds
a B.A. from Flinders University and
an M.A. from the University of Tech-
nology, Sidney. Inspired by the Dada
experiments and Marcel Duchamp's
assisted readymades of the early 20th
century, Tipping is an artist who
comments and subverts the status quo
on multiple fronts. From small-scale
sculptures, to photographic series,
to full-blown outdoor installations,
he has explored a variety of media,
including light, stones, and found
commercial objects. Many of his
works incorporate text and poetry of
his invention. The presence of a dry
wit and fanciful punning is clearly
evident in *Peace Pipe*, where the

title is engraved in gold leaf along
the handle of a claw hammer, or in
Drill-a-Phone, which substitutes a
drill for the handle of an old-
fashioned telephone. His work has
been shown throughout Australia,
London, and the United States. The
recipient of several public art
commissions and awards, he is also
represented worldwide with prints,
multiples and sculptures in numerous
public and private collections. In
addition he has produced film and
video documentaries, books, and
temporary public art projects, in-
cluding the 54-foot-long banner, *Art
is a Pane in the Glass*, for the 9th
Sidney Biennale, in 1992-1993.

Plane
1978

F. L. Wall

F. L. Wall was born in Dover, Delaware, in 1947. He received a B.A. from the University of Delaware in 1969, and has also studied sculpture at the Corcoran School of Art in Washington, D.C., in 1980-81. Wall started his career restoring antiques and building eighteenth-century reproductions in Williamsburg, Virginia. He eventually began designing his own furniture, which was inspired by the Scottish Arts and Crafts artist Charles Rennie Mackintosh and the twentieth-century Japanese-American wood master George Nakashima. 1975 he began to carve a series of over-sized, recognizable objects, such as tools and a gas pump, in wood. While their play with scale and medium recalled the Dadaist experiments of Man Ray and the work of Pop artist Claes Oldenburg, their exquisite craftsmanship encouraged viewers to see the inherent beauty of their shapes and materials. Since 1979 he has exhibited his work widely, including shows at the Corcoran Gallery of Art, Washington, D.C., and the Virginia Museum of Fine Arts in Richmond. Humor and surprise continue to be guiding elements in his work, which includes purely sculptural pieces. The latter range from abstracted chair forms to tabletop sculptures that incorporate various woods and steel and function as three-dimensional still lifes.

Two Hands with Pliers
1995

David Webster

Born in Wadsworth, Ohio, in 1947, David Webster earned an M.F.A. from Yale University and a B.F.A from Miami University. After living in France for 22 years, he returned to New York. Equally adept in painting, sculpture, works on paper, he is the recipient of several commissions and a Pollack-Krasner Grant. He has participated in several exhibitions at the Contemporary Museum, Baltimore, Pittsburgh Art Center, the Islip Art Museum, and P.S. 1 Museum, New York, among others. His work is in collections throughout Europe and the U.S. In the eighties, his work reflected an interest in mythology, primitive religion, and architecture, exploring such themes as ecology, gender, and health through a distilled, often, multi-part, geometry of symbols. Since the nineties, his imagery has concerned itself with the human body, with light making a frequent appearance in his work. One series exploits the transformative illumination and pictorial qualities of the X-ray to present his own hands and feet as metaphor and language. In *Two Hands with Pliers*, anatomy dissolves into a ghostly arabesque only to be jolted by the image of pliers pulling out a nail apparently lodged in a under a fingernail (a pun on fingernail and hardware nail). For the last five years, his painting has addressed histology, the microscopic study of cells, interpreting complex processes and pathways through lush paintings of biomorphic abstraction.

H.C. Westermann

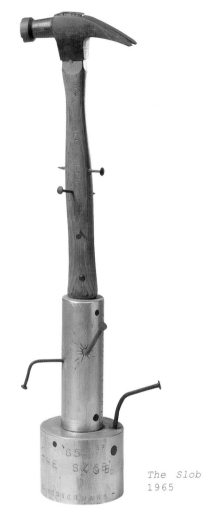

The Slob
1965

H.C. Westermann was born in Los Angeles in 1922 and died in 1981. His highly idiosyncratic aesthetic encompasses autobiography, folk art, and popular illustration as well as aspects of Dada and Surrealism. The early work of this master of assemblage anticipated Pop Art by nearly a decade. He studied at the School of the Art Institute of Chicago from the 1947 to 1954, working off and on as a carpenter, a plasterer, and a general handyman. In 1953 he began making sculptures. His works from the early 1950s, such as a series of carved "Death Ships," were inspired by his war experiences. Around 1956 he started a series of eccentric "houses" or "towers" that served as containers for feelings and dreams. In the 1960s he explored mock-heroic imagery, like his deified Coca-Cola bottle. Other sculptures depict sinister robot gods or refer to such diverse elements as ships' helms, tables, and boxes. After 1957 he exhibited frequently in the United States, especially in Chicago, the Los Angeles County Museum of Art, and the Corcoran Gallery of Art in Washington, D.C. He was the subject of a traveling show in 1976 and in 2001, the latter being accompanied by a monograph. His mature work continues to be marked by irony and paradox as well as exquisite craftsmanship.

Toothpick
1986

Robert Wideman

Robert Wideman was born in Albany, New York, in 1953 and studied at the State University of New York. Since 1976 he has designed and created objects of ferrous materials while teaching metalsmithing on his own and in association with the Hancock Shaker Museum and the Old Chatham Shaker Museum. In addition to making his own sculptures, he works on commissions and develops armatures and components for other sculptors. In one series, he transformed recognizable tools and mechanisms into new dynamic objects that have great beauty, wit, and an organic quality that contrasts with their original, functional design.

William T. Wiley

Eerie Grotto Okini
1982

William T. Wiley was born in Bedford, Indiana, in 1937. He studied at the San Francisco Art Institute and earned his B.F.A. in 1961 and his M.F.A. a year later. Since 1960 he has participated in numerous exhibitions at the San Francisco Museum of Modern Art, the Philadelphia Museum of Art, and the Corcoran Gallery of Art, Washington, D.C., among others. His work can be found in collections worldwide, including the Art Institute of Chicago, the Hirshhorn Museum and Sculpture Garden in Washington, D.C., the National Gallery in Victoria, Australia, the Stedelijk Museum in Amsterdam, and the Whitney Museum of American Art in New York. Wiley was a founding member, along with Robert Hudson and William Allen of the San Francisco Neo-Dada Funk Art Movement of the 1960s. These prickly artist activists delight in the absurd and the incongruous, while Wiley's sense of fantasy recalls the pre-Surrealist dreamscapes of Giorgio de Chirico. His densely layered paintings and prints depict imaginary worlds and cosmic struggles, complete with hermetic symbols and often often-humorous observations scrawled within the images and in the margins. His equally inventive sculptures also address the enchantment of the mundane. Over the years, Wiley's influence has been pervasive, especially with the New Image generation of the 1970 s and 1980s.

*Paint Can with
Brush*
1981

Phyllis Yes

Born in Redwing, Minnesota, in 1941, Phyllis Yes received an M.A. from the University of Minnesota in 1969 and a Ph.D. from the University of Oregon in 1978. Although primarily a painter, Yes also makes sculptures and videos. She has been awarded a National Endowment for the Arts grant and an Oregon Arts Commission Fellowship. Her work has been widely exhibited in the United States, Japan and South America. She is a professor of art and dean of Art & Humanities at Lewis & Clark College, Portland, Oregon. Yes's work addresses the issues of femininity and gender identification. She uses tools to symbolize masculinity in her paintings and objects, then sabotages them by overlaying them with webs of lacy patterns and motifs traditionally thought of as feminine. Yes once gave a lace paint job to a Porsche and in the 1980s she "decorated" a variety of tools with her floral and lace patterns. In a series of paintings, "Mixed Metaphors," Yes depicted detailed table settings where tools replaced silverware, thus contrasting men's and women's traditional family roles.

Checklist

Page.	TITLE	ARTIST	DATE	MATERIALS	DIMENSIONS
18	Hardware Store	Berenice Abbott	1938	Gelatin silver print	10 1/2"x13 1/2"
19	Blue, Red, Brown	Arman	1988	Acrylic with paintbrushes on canvas	54"x42 1/2"
21	Correction	Chester Arnold	1987	Oil on linen	46"x54"
22	Stair Ladder Barricade	Yuri Avvakumov	1989-93	Screenprint	22"x30"
23	Reliquary/Pier 48 Hudson River	Barton Lidicé Benes	1982	Mixed media on paper	30"x22"
24	Now the Lord God Planted a Garden....	Charlie Brouwer	1992	Treated and stained wood	72"x50"x6"
25	Saw Blades/Scythe/Guitar	Ken Butler	1994	Hybrid instrument	39"x30"x5"
26	The Long Road to Usefulness	Hugh R. Butt	1989	Painted steel and hardware	57"x31"x8 1/4"
27	The Plumber	Roy Carruthers	1980	Colored pencil on muslin-faced paper	41 1/4"x22"
28	Paint Can and Tools	James Carter	1988	Acrylic on canvas	21" x 21 1/2"
29	Hand-Tooled Jacket II	Debra Chase	1982	Wire mesh, aluminum and acrylic resin	46"x35"x2"
30	Untitled (from the Kharmasiada Series)	Andrey Chezhin	1994	Gelatin silver print	5 7/16"x11"
31	The Clampdown	Graham Crowley	1983	Oil on canvas	60"x48"
32	Brush and Tub	Dies de Jonge	1982	Wood	14"x6"
33	Leontine	Wim Delvoye	1990	Enamel on circular saw with ceramic base	18"x15"x6"
35	New French Tools 3 - For Pep	Jim Dine	1984	hard-ground etching with dry point and aquatint	36 1/6"x25"
36	Jack	Greg Drasler	1987	Oil on canvas	70"x50"
37	Hammer Breaks Glass Plate	Harold E.Edgerton	1933	Gelatin Silver Print	24"x20"
38	Kotoko	Melvin Edwards	1994	Welded Steel and Paint	16"x11"x8"
39	Near the River at Greenville, Miss	William Eggleston	1986	Type C print	16"x20"
40	Old Handyman's Tea	Glenn Elvig	1993	Mixed Media	24"x14"x6"
41	Nass Linoleum	Richard Estes	1972	Screen print	14"x17"
43	Wrench (from 'Beauties of the Common Tool", Fortune, July 1955)	Walker Evans	1955	Gelatin silver print	10"x8"

Page.	TITLE	ARTIST	DATE	MATERIALS	DIMENSIONS
44	Women in Labor	Henryk Fantazos	1986	Oil on canvas	40"x51"
45	Mountains of People Use Tools	Howard Finster	1990	Enamel and marker on saw	6"x29 3/4"
46	Hammer and Nails	Hans Godo Fräbel	1980	Glass	9"x12"x6"
47	Tornado	Ke Francis	1991	Woodcut on handmade pigmented paper	30"x40"
48	Untitled (Oak)	Peter Gryzybowski	1990	Oil on canvas	50"x36"
49	Stepladder with Can and Brushes	Pier Gustafson	1982	Paper construction with pen and ink	38"x20"x18"
50	Zu Kafka's Verwandlung	HELMA	1994	Oil on canvas	59"x41"
51	Watchtower	Tracy Heneberger	1995	Hinges and screws	54"x18"x9"
52	Dreamtime	Lou Horner	1991	Acrylic on wood	13"x57"
53	Anonomalous Fossil No.2	Ben Jakober	1986	Stone	20 1/4"x13 1/8" x2 1/2"
54	Untitled	Jacob J. Kass	1981	Acrylic on saw	7"x26"
55	Power Tool Baby	Mark Kostabi	1989	Oil on canvas	54"x48"
56	Two-Hand Saw	Oleg Kudryashov	1979	Drypoint contruction	72"x24"
57	Carpenters	Jacob Lawrence	1977	Lithograph	18"x22"
59	Les Constructeurs	Fernand Léger	1951	Lithograph	17 1/2" x 23"
61	Untitled (Saw)	Donald Lipski	1994	Metal saw and pink raffia	54"x7 1/2" x 3/4"
62	Homage to the Industrial Revolution #2 - Drill Press	Mark McDowell	1986	Acrylic on canvas	72"x 60"
63	Zen Saw II	John Mansfield	1986	Rock, rice paper and balsa wood	25" x 19" x 14"
64	Cure All	MANUAL	1984	Type C print	13 1/2" x 9 1/4"
65	Paintbrush Portraits	Mr. Imagination	1991	Mixed media with paintbrush	
	Paintbrush Portrait with Shell Earrings				12" x 4 1/2" x 3"
	Grinning Paintbrush Portrait				10" x 3" x 3"
	Paintbrush Head with Copper Tiara				12" x 3" x 1"
	Paintbrush Head with Earrings				11" x 8" x 3"
	Paintbrush Portrait with Tongue				9" x 4" x 2"
67	Three-Way Plug	Claes Oldenburg	1965	Offset lithograph with airbrush	32" x 24 1/2"
68	Hand and Hammer	Tom Otterness	1993	Engraving and drypoint with Chine Colle	16 1/4" x 15"
69	Still Life with Tenon Saw	Christopher Plowman	1985	Varnished steel	24" x 30" x 24"
	Cut	" "	1986	Polished steel	25" x 48" x 21"
70	Self-Portrait in the Bathtub	Clayton Pond	1981	Silkscreen	19" x 24"
71	Saw and Axe	Kaisa Puustak	1987	Aquatint	14" x 20"
72	I Nailed Wooden Suns to Wooden Skies	Red Grooms	1972	Polymer and collage on paper	21 1/2" x 31"
74	Siamese Hammer Joined at the Handle	Vladimir Salamun	1982	Red oak and claw hammer heads	6" x 14" x 6"
75	Untitled (Hand/Eye)	John Schlesinger	1992	Gelatin silver print on circular saw	19" diameter
76	Crosscut Saw	Lee A. Schuette	1982	Wood	11" x 34" x 2"
	Rake Back Chair #2	" "	1981	Oak, synthetic grass and rake	35" x 21" x 17"
79	Rinse Cycle	Roger Shimomura	1988	Acrylic on canvas	60" x 24"
80	Veteran's Building Boiler Room #126	Rico Solinas	1994	Oil on metal	5 1/2" x 30"
81	Rebuilding	James Surls	1991	Carved and burned magnolia wood	36" x 29" x 29"
83	Paint Cans	Wayne Thiebaud	1990	Lithograph	39" x 29"
84	Drill-a-Phone	Richard Tipping	1990/ 1997	Telephone with hand-drill	7 1/2" x 15" x 8"
85	Plane	F. L. Wall	1978	Cherry, maple, walnut, and yellow pine	48" x 20" x 14"
86	Two Hands with Pliers	David Webster	1995	Mixed media with lightbox	10 1/4" x 7 1/4" x 4"
87	The Slob	H.C. Westermann	1965	Hammer,nails and aluminum	22" x 4 1/2" x 4 1/2"
88	Toothpick	Robert Wideman	1986	Steel and Wood	34" x 28"
89	Eerie Grottoo Okini	William T. Wiley	1982	Woodblock print	22" x 30"
90	Paint Can with Brush	Phyllis Yes	1981	Mixed media with paint can and brush	9" x 11"